C000133777

Paper Crystals

How to make enchanting ornaments from simple units made by folding paper

David Mitchell

2nd Edition

Revised and expanded 2012

A Water Trade publication
www.watertradebooks.co.uk

Paper Crystals

How to make enchanting ornaments from simple units
made by folding paper

David Mitchell

2nd Edition
Revised and expanded 2012

A Water Trade publication
www.watertrade.co.uk

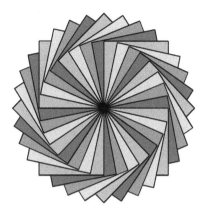

About Water Trade

Water Trade is a micro-publisher of books about aspects of origami and paperfolding. We aim to publish books containing original material of the highest quality organised around technically interesting or unusual themes, and which are consequently far more than simply collections of instructions for designs. We welcome submissions from new or established authors on potential themes for future books.

About David Mitchell

David Mitchell has been a professional author, illustrator and designer specialising in origami for many years. He lives in Kendal, close to the mountains of the English Lake District, where he loves to walk. He is also a passionate fan of latin dance and music, particularly salsa and bachata.

As a designer he is particularly well known for his innovative modular and macro-modular sculptures but is also a prolific inventor of single and multi-piece paperfolds, action novelties and puzzles.

His other books include Complete Origami, Mathematical Origami, The Magic of Flexagons, Paperfolding Puzzles, Origami Animals, Building with Butterflies, Origami Alfresco, Paper Planes, and Sticky Note Origami.

David Mitchell can be contacted through his website www.origamiheaven.com

Contents

Regular designs

Irregular designs

Introduction

Paper Crystals are attractive and visually intriguing sculptures made by combining several, or sometimes many, folded paper units, or modules, into an integrated three-dimensional form, a technique that is known as modular origami.

Modular origami assemblies of this kind are often called kusudama, but this name should strictly be reserved for those modular assemblies which resemble balls of flowers (which is what the word kusudama means). In looking for an alternative I was struck by the similarity between the highly structured nature of modular origami designs and that of naturally occurring mineral crystals. This similarity arises because Paper Crystals are closely based on three dimensional mathematical structures called polyhedra. It is this underlying structure that gives Paper Crystals their strength and stability.

In addition to this book, all you need to start creating Paper Crystals of your own is a supply of square origami paper, which you can easily buy online or in the high street, in packs of assorted colours. Most paper that comes in packs of this kind is what I call irogami, paper that is white on one surface and coloured on the other. Sometimes, however, it is paper that has been over-printed with the same plain colour on both surfaces or made from dyed fibres (with the result that it is the same colour on both surfaces and all the way through). All the designs explained in this book can be made from all these types of paper but in order to make the folding diagrams as clear as possible they have been shaded as if the designs were being folded from irogami.

For the same reason the diagrams show you how to assemble each of the crystals as if you were combining a number of sets of modules folded from paper of several contrasting but complementary colours (represented by modules shaded in different tones of grey). This helps make the instructions clear, but it is not necessarily the best way to show the structure of the crystals off to their best advantage. Many of them will look at their best when folded from a single colour and design of patterned paper. You could also try experimenting with a patchwork effect. Choosing the perfect paper to fold a modular origami design from is a skill in itself.

There are two different ways to approach this book. If you are new to modular origami your main interest will probably be to learn to fold and assemble the designs in your own choice of paper and to a standard that produces beautiful results that you can display in your office or home, or give to your friends as

gifts. If you are already a modular origami aficionado I hope you will want to do exactly the same, but I also hope your interest will extend to a consideration of the design techniques that have enabled me to create them.

The first edition of Paper Crystals was written to show just what the modular origami technique can do, how varied the results can be and how powerful a tool it is for the design of original sculptural form. In deciding which designs to retain, which to omit and which new material to add to this second edition I have had exactly the same aim in mind.

I have ended up omitting three designs from this second edition, Metamorphosis (because I have already included it in the second edition of Building with Butterflies where it more properly belongs), Cloud of Stars (because I have developed a more robust version which will be published in another book, along with other related designs, in due course) and Sappho (which is replaced by Zigzag, a simpler and better version of the same modular idea).

Where I have added material it has often been for the sake of completeness (although I have not added any designs which do not deserve their place on merit). Thus, for instance, I have not only included Gemini and Gemini 24 (from the first edition) but also added Gemini 60 and 12. Similarly, I have added Andromeda 60 and a third, though actually the original, method of making the Enigma Cube, which is now known as Enigma 2. I have also included the Semi-Star (because it is the design on which Andromeda depends) and Gaia (because it comes from the same complex base as Enigma 2).

All these designs are regular (in the sense that they are all made from a single set of identical modules). In order to extend the range of creative techniques showcased in this book I have also included three designs that are irregular (in the sense that they are made from several different sets of modules) and these have been given a section of their own. Andromeda could have been placed in either section. I have, however, chosen to treat it as a regular design on the basis that the corner caps are best regarded as decorative enhancements rather than essential to the structure of the design.

Perhaps I should at this stage add an explanatory note about names. Several of the modules, Electra and Gemini for instance, can be used to create a set of closely related forms made from differing numbers of modules of the same, or essentially similar, design. I call such a set of designs a suite and in order to

distinguish between the designs in a suite I have adopted the convention of adding the number of modules used to the name of the design. Thus Gemini 60 is the member of the Gemini suite that is made from 60 modules. This is not foolproof, since it is possible to have two forms within a suite that are both made from the same number of modules, but it is a nonetheless a useful convention to adopt. I have, however, usually retained the original simple name for the primary suite member. Thus I have retained the primary name Electra as the name for the thirty module member of the Electra suite rather than using its technically correct name of Electra 30. This inconsistency has allowed me to continue using the established names for designs that may already be familiar to modular origami aficionados.

Although the designs in this book are very varied there are several themes, or design motifs, that are common to groups of the designs and are worth mentioning here.

Four of the designs, Gaia, Omega 12, Enigma 2 and Enigma 6 are somewhat unusual in that the development of the form continues after the modules have been put together. Aurora can also be made in this way. Cloud of Stars, which has been omitted from this book, is also a design of this kind.

Five of the designs, Proteus, Gaia, Electra, Odyssey and Curvaceous have openings, or windows, in the surface, which allows light into and through the sculpture and creates internal space and structure. In these cases the structure and texture of the interior space was largely an accidental product of the design process, but there is no reason why interior space should not be as carefully designed as the exterior surface.

Finally, it is also worth noting that three of the designs in this book, Spiral Cluster, Curvaceous and Q, are made from compound modules (second generation modules that are made by combining two or more sets of first generation modules).

I have also tried to include designs which use a variety of folding geometries (a folding geometry is a system of angles created by, and used in, folding paper) and in particular to include hybrid as well as uniform designs. Uniform designs make use of a single folding geometry while hybrid designs mix two or more.

All but one of the uniform designs in this book, which include Spiral Cluster, Aurora, Gemini, Enigma, Zigzag, Omega 12 and Q, are folded using standard

folding geometry (folding geometry that is based on angles of 90 and 45 degrees). The odd one out is Proteus, which uses folding geometry based around 60 and 30 degree angles (which I call bronze folding geometry because it is most naturally derived from the bronze rectangle).

The situation with the hybrid designs is more complex. The modules for the Semi-Star, Andromeda and Electra, for instance, are all designed using a mix of standard folding geometry and what I call mock platinum folding geometry (which produces a close approximation of 72 and 36 degree angles), while Gemini 12 is folded using a mix of standard and bronze folding geometries.

The hybrid folding geometries of Odyssey and Curvaceous, on the other hand, are closely related to their compound nature. In both cases the compound modules are made by combining A modules folded using standard folding geometry with B modules folded using silver folding geometry (folding geometry that is most naturally derived from the silver rectangle).

Whichever way you care to use this book, whether you are a modular origami novice or already an expert, I hope you will enjoy folding my Paper Crystal designs as much as I enjoyed creating them. The less said about the joys of diagramming them the better.

My thanks are due to David Brill for allowing me to include his wonderful 12-part Enigma Cube design.

David Mitchell

How to understand the folding instructions

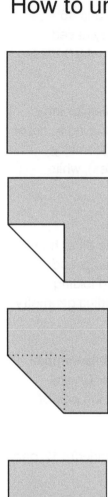

The edges of the paper are shown as solid lines.

1

Each picture is numbered. You should be careful to read them in the correct order.

Shading is used to show which side of the paper is coloured.

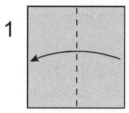

1

A folding instruction consists of a movement arrow, a fold line and a written explanation that may contain information not shown in the picture.

1. Fold in half sideways.

Dotted lines are used to show hidden edges and fold lines or imaginary lines that are used to help locate a fold.

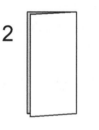

2

This is the result of following the instruction above. Edges which lie exactly on top of each other as the result of a fold are sometimes shown slightly offset on the after diagram.

A movement arrow shows you which part of the paper moves and where it goes to.

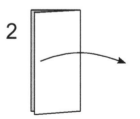

2

A movement arrow without a fold line means unfold in the direction indicated.

A fold line shows you where the new crease will form when you flatten the fold. A dashed fold line means the fold is made towards you. You should always flatten the fold unless you are told not to.

This picture also shows you how a single picture can show you the result of making the previous fold as well as how to make the next one.

Creases you have already made are shown as thin lines.

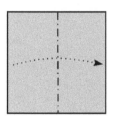
This version of the movement arrow means fold, crease, then unfold.

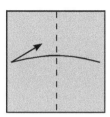
A dashed and dotted fold line means that the fold should be made away from you.

The movement arrow that goes with this picture is shown with a dotted shaft because the fold is made behind the paper.

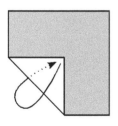
This picture tells you to swing the flap backwards out of sight by reversing the direction of the existing crease.

The eye symbol tells you that the next picture is shown from a different angle.

A combination of forwards and backwards fold lines show you how the paper can be collapsed into a different shape.

The ruler symbol shows that the adjacent edge should be seen as divided into a number of equal sections.

This symbol tells you to apply gentle pressure to the paper in the direction the arrowhead is pointing.

This arrow tells you to pull some part of the paper gently in the direction the arrow is pointing.

This symbol tells you to turn the paper over. The written instruction will tell you in which direction.

A circle is used to draw attention to some particular part of a picture referred to in a written explanation.

This symbol tells you that the next diagram has been drawn on a larger scale.

Polyhedra referred to in the projects

Octahedron

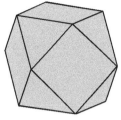

Cuboctahedron

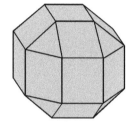

Rhombicuboctahedron

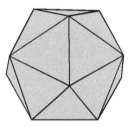

Icosahedron

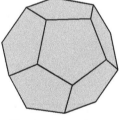

Dodecahedron

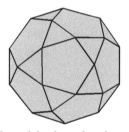

Icosidodecahedron

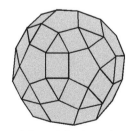

Rhombicosidodecahedron

Cuboctahedron

Octahedron

Icosahedron

Rhombicuboctahedron

Icosidodecahedron

Dodecahedron

Rhombicosidodecahedron

Regular designs

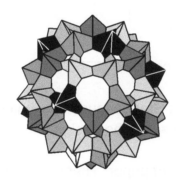

The Semi-Star

I discovered this design in 1987 when I was playing around with Robert Neale's Octahedron. In trying to vary his design I found that it was possible to turn two arms of the module outwards to create points, without affecting the way in which the modules would go together. The result is an unusual, hybrid sculpture in which the twelve points of the star protrude from the edges of a nolid octahedron.

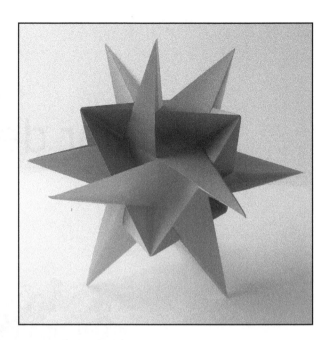

I call this design the Semi-Star because only half of each of the twelve points of the star are present in the design.

You will need six squares of paper. These diagrams show you how to make the Semi-Star using two squares in each of three contrasting but complementary colours. If the Semi-Star is made from irogami some of the white surface of the paper will be visible on the exposed inside surfaces of the points.

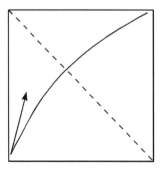

1. Fold in half diagonally, then unfold.

2. Fold in half diagonally in the opposite direction, then unfold.

3

3. Turn over sideways.

4

4. Fold in half downwards, then unfold.

5

4. Fold in half from right to left, then unfold.

6

5. Turn over sideways.

7

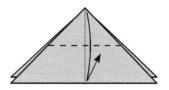

7. Collapse and flatten into the form shown in picture 8.

8

8. Fold the top point down to the centre of the bottom edge, then unfold.

9

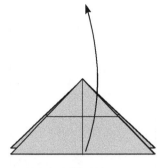

9. Open out completely.

10

10. Change the direction of these three sections of crease so that they become ridges rather than furrows.

11

11. Add four new creases in the way shown here. Try to make these as cleanly and accurately as possible.

12

12. Turn over sideways.

13

13. Fold the bottom left corner inwards like this, then unfold. Make sure your creases do not enter the central square.

14

14. Repeat step 13 in the opposite direction.

David Mitchell / Paper Crystals

15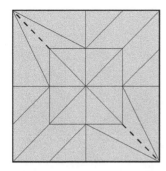

16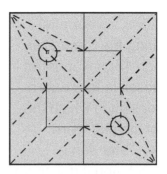

15. Reverse the direction of these two sections of diagonal crease so that they become furrows rather than ridges.

16. Collapse into the shape shown in picture 17 making sure you do not reverse the direction of any of the creases. The centre rises up towards you and the points marked with circles sink away from you.

17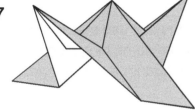

18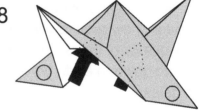

17. You will need six modules like this, two in each of three colours.

18. Each module has two tabs and two pockets. The tabs are marked with circles and the pockets are indicated by arrows.

19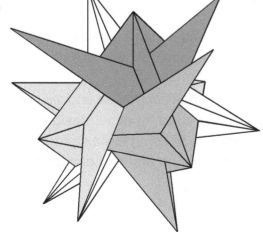

19. The tabs of one module go into the pockets of two other modules. Begin by putting three modules together to form one face of the central octahedron, then continue to add modules until the Semi-Star is complete. You will find that this assembly process is straightforward. Just be careful of the points, which are easily damaged.

Andromeda

In late 1988, a year after discovering the Semi-Star (see page 16), I wondered if it was possible to create a similar design in which the points of the star were complete. After some experimentation it did prove to be possible, but only by virtue of changing both the design of the modules and the modular method. Instead of the six modules of the Semi-Star, this new design, which I christened

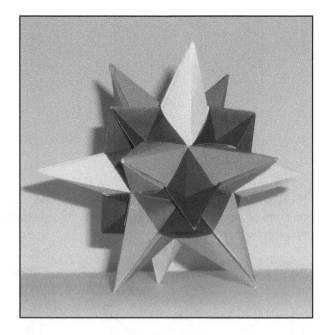

Andromeda, now required twenty-four. As a result it had also lost the ethereal quality of the Semi-Star and turned into something much more robust and down to earth (which is somewhat odd for a design named after a galaxy).

In 1995, while preparing the first edition of this book, I added corner caps (which are just waterbomb bases folded from blintzed squares). This not only tidied up the appearance of the corners of the central octahedron but also improved the look of the design by differentiating this central octahedron from the radiating points.

Finally, In 2011, while preparing this second edition, I realised that the corner caps could be redesigned to make more efficient use of the paper.

You will need twenty-four squares for the basic modules and six more of the same size if you choose to add corner caps, of either design. The diagrams show you how to make Andromeda using eight squares in each of three contrasting but complementary colours and corner caps made from black or dark blue paper.

Folding the modules

1

1. Fold in half, then unfold.

2

2. Fold in half diagonally, then unfold, but only crease half of the fold like this.

3

3. Fold in half diagonally in the opposite direction, then unfold, but only crease half of the fold like this.

4

4. Fold all four corners to the centre.

5

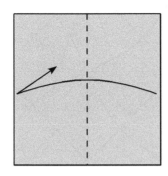

5. Fold the right corner inwards so that a new crease forms between the two points marked with circles.

6

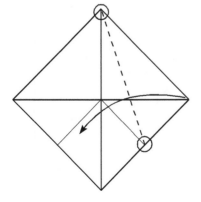

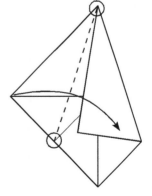

6. Fold the left corner inwards in a similar way.

7

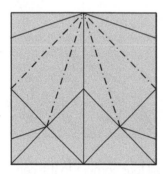

7. Undo the folds made in steps 5 and 6.

8

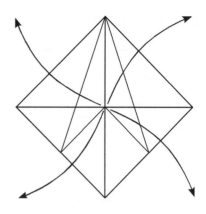

8. Open out the folds made in step 4.

9

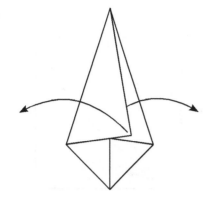

9. Reverse the direction of these four creases so that they become ridges rather than furrows.

10

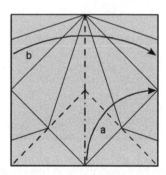

10. Make fold a then fold b to collapse the paper into the shape shown in picture 11.

11

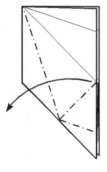

11. Fold the front layer across to the left and arrange to look like picture 12.

12

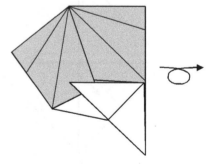

12. Turn over sideways.

13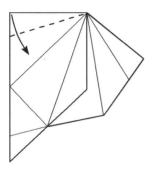

13. Fold the top edge downwards using the existing crease.

14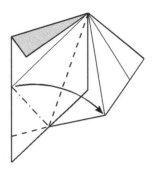

14. Fold the left edge across to the right and arrange to look like picture 15.

15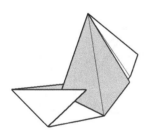

15. The Andromeda module is finished. You will need twenty-four, eight in each of three colours.

Forming the points

Although, for the sake of clarity, the diagrams in this section show the two modules in different tones of grey you should make each point out of two modules of the same colour.

16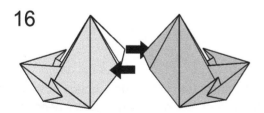

16. Two modules go together to form one point of the star like this.

17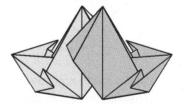

17. As you put them together make sure the nearest flap of the left-hand module and the farthest flap of the right-hand module end up outside the assembly. Make sure that all the corresponding parts of each module match up inside.

18

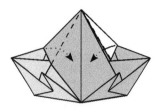

19

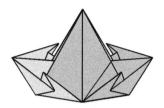

18. Both outside flaps tuck into the pockets to lock the modules firmly together.

19. This was only practice. Once you understand how the points are formed take the modules apart again.

Making the sub-assemblies

Andromeda is built by combining six sub-assemblies, each of which is made from four modules.

20

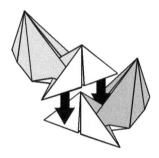

21

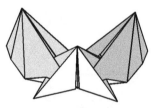

20. Two modules go together like this.

21. The modules should nest together on the inside and the outside.

22

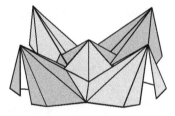

22. The third and fourth modules are added in the same way. The fourth module is then tucked underneath the first module to complete the sub-assembly ring. You will need to check underneath the sub-assembly that all the layers are nested accurately. Assembly is much easier if you hold the modules together with paper clips or small strips cut from the adhesive coated sections of a sticky note during the assembly process.

You will need to make two sub-assemblies by combining modules of colours one and two, another two by combining colours two and three and finally two more by combining colours one and three.

Folding and adding the original corner caps

23

22. Fold in half diagonally, then unfold. Repeat in the opposite direction.

24

24. Turn over sideways.

25

25. Fold in half sideways, then unfold. Repeat in the opposite direction.

26

26. Fold all four corners into the centre.

27

27. Turn over sideways and arrange to look like picture 28.

28

28. Collapse into the shape shown in picture 29. The centre of the paper rises up towards you as you do this.

29

29. This is the finished original corner cap. Make sure that the central corners of the internal layers all lie flat. Make six.

30

30. Each corner cap fits into the centre of a sub-assembly like this.

31

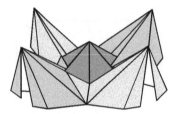

31. You will not need to use paper clips or strips cut from sticky notes to hold your sub-assemblies together if you are using original corner caps.

Folding and adding the new corner caps

32

32. Begin with steps 23 to 25 then turn over sideways.

33

33. Fold all four corners into the centre, then unfold.

34

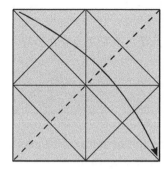

34. Fold in half diagonally.

35

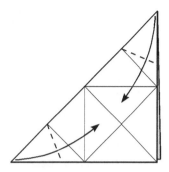

35. Fold both the top right and bottom left corners inwards as shown. Picture 36 shows what the result should look like.

36

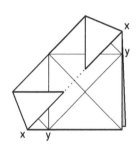

36. Check that the edges of the front flaps both lie on line xx which is parallel to crease yy. Adjust if necessary.

37

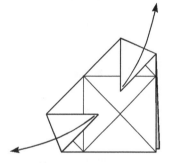

37. Open out the folds made in step 35.

38

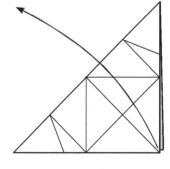

38. Open out the fold made in step 34.

39

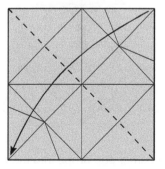

39. Fold in half diagonally in the other direction then repeat steps 35 to 38 on the other two corners.

40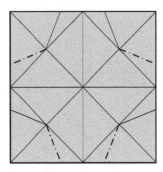

40. Reverse the direction of these four small creases so that they become ridges rather than furrows.

41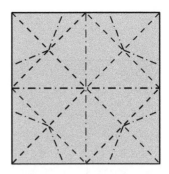

41. Check the direction of all these creases is as shown here.

42

42. Collapse by pinching the sides of the vertical and horizontal creases together like this. The centre rises up towards you as you do this.

43

43. The points marked with circles should sink. Pull the corners up towards you slightly to persuade the paper to settle into shape.

44

44. The corner cap drops into the centre of the sub-assembly.

45

45. If you are using new sub-assembly caps you will find it helpful to use paper clips to hold the sub-assemblies together during the assembly process.

David Mitchell / Paper Crystals

Assembling Andromeda

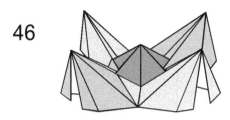

46

46. The sub-assemblies are joined together by tucking the free flaps of one inside the pockets of another to form points between them. Once you have linked two modules to form a point you may find it useful to hold them together with small strips cut from the adhesive section of a sticky note. These strips can be removed once the assembly is complete.

47

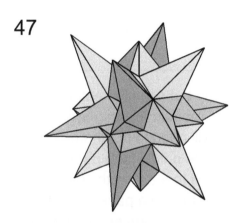

48

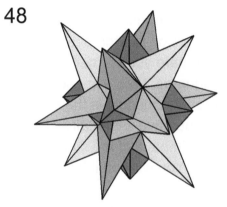

47. This is what Andromeda looks like when made from eight modules in each of three colours, without corner caps.

48. This is what Andromeda look like when the original corner caps have been added.

49

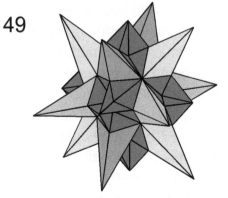

49. And this is what Andromeda looks like when it has been augmented by the addition of new corner caps.

Andromeda 60

It had long seemed possible to me that sixty Andromeda modules would go together to form a thirty pointed star (Andromeda 60) based around the geometry of the icosahedron, but I did not find time to try this possibility out until early 2012 when I was finalising this book. The result was worth the wait.

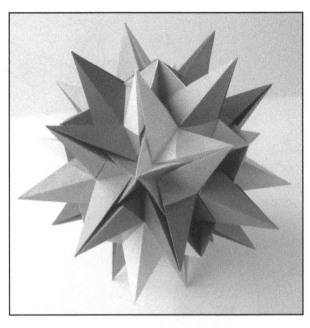

If you want to make a five colour version like the one pictured here you will need sixty squares, twelve in each of five contrasting but complementary colours. The module is the same as the basic module for Andromeda. When you have folded all sixty modules you will need to put them together in pairs of the same colour to create the points (see pages 23 and 24). You will find it helpful to hold the points together with strips cut

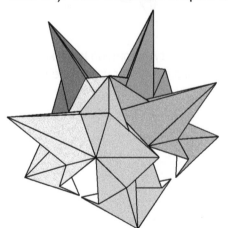

from sticky notes. Five pairs of modules then go together to form one corner of the underlying icosahedron like this. I would recommend that you also use strips cut from sticky notes to hold these corners together. Add five further pairs of modules around the edge of the first ring, then continue to add modules until the design is complete, remembering that five modules meet at each corner of the underlying icosahedron. The colour scheme is the same as that for Zigzag (see page 70). You should remove the strips from the points as soon as the assembly process allows (since this will otherwise prevent the design from forming properly). The strips holding the corners together can be left there until the assembly is complete.

David Mitchell / Paper Crystals

Spiral Cluster

The twin forms of Spiral Cluster will be familiar to anyone who is acquainted with modular origami. What makes Spiral Cluster different is that it is made from compound modules (modules that are built by combining other modules). This has allowed me to create a pattern on the surface of the stars in which each element of each spiral is made from a separate sheet of paper, so that each

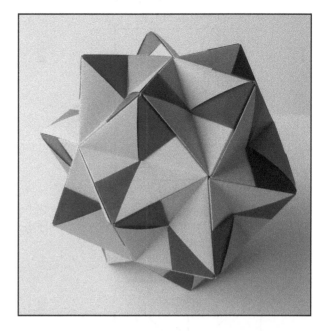

of the spirals can be a different colour. This also allows the spirals to be separated from each other by a single background colour. The downside of such a strategy is that a large number of modules are required, the upside that each module is extremely easy to fold. The overall design is equally easy to assemble, but nonetheless robust when complete.

I created this design in 1999. The design of the modules, and the way in which they are combined to create a compound module, is directly related to the techniques used to build many of the sculptures in my book Building with Butterflies, which I was working on at that time.

For the smaller cluster you will need forty-eight squares of paper, twenty-four for the background and six in each of four contrasting but complementary colours for the spirals.

For the larger cluster you will need one hundred and twenty squares of paper, sixty for the background and ten in each of six colours for the spirals.

I would suggest using black or dark blue for the background colour.

Folding the basic modules

1

1. Fold in half diagonally, then unfold.

2

2. Fold in half diagonally in the opposite direction, then unfold.

3

3. Fold in half from right to left, then unfold.

4

4. Fold in half upwards, then unfold.

5

5. Fold the top left corner into the centre.

6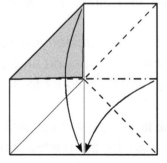

6. Collapse and flatten like this using the existing folds.

7

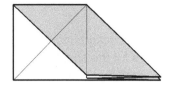

7. The finished basic module should look like this.

Assembling the compound modules

Each compound module is made from four basic modules, two of the background colour and two that will form part of the spirals, which should be of different colours.

8

9

8. Begin by putting two modules together like this. The back flap of the left hand module goes inside the back flap of the right hand module. The front flap of the right hand module goes inside the front flap of the left hand module.

9. Put two more basic modules together in the same way then slide the two sets together like this. The two flaps at the back also slide into pockets.

10

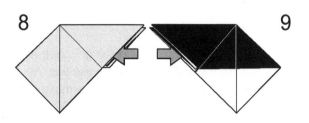

11

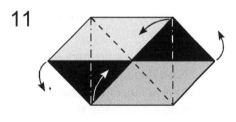

10. Check that the compound module now has pockets in the positions shown and that these pockets are secure.

11. Configure the compound module like this. These folds will also act to hold the four basic modules together.

12

12. One compound module is finished.

Assembling Spiral Cluster 48

You will need forty-eight squares of paper, twenty-four in the background colour and six in each of four other contrasting but complementary colours for the spirals. These should be assembled into twelve compound modules. Each compound module should be made from two modules of the background colour and two of different colours from those chosen to form the spirals. Two compound modules of each possible colour combination are required. You can either make up the complete set in advance or put them together as and when they are required during the assembly process.

13

13. Four compound modules go together to form the first spiral pattern like this. All the basic modules forming the arms of the spiral should be the same colour. The basic modules forming the outer edges of the compound modules should be of two different colours, arranged so that modules of the same colour are on opposite sides of the assembly.

14

14. Add another compound module to form a three-sided pyramid at each side of the spiral. The colours of these compound modules should match the colours already present at the corners of the spiral. Once the pyramids have been formed the assembly will not lie flat.

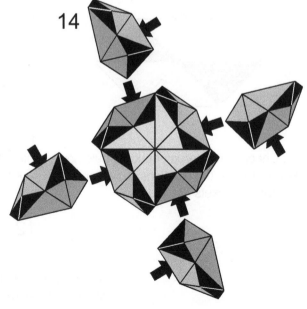

15

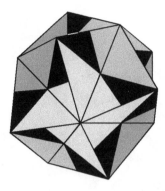

15. Continue creating four-armed spirals and surrounding them with pyramids until the cluster is complete. In this pattern spirals of the same colour are placed on opposite sides of the cluster.

16

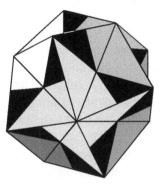

16. You can vary the design by making all the spirals in the same colour or by making them each a different colour like this.

Assembling Spiral Cluster 120

You will need one hundred and twenty squares of paper, sixty in the background colour and ten in each of six contrasting but complementary colours for the spirals. These should be assembled into thirty compound modules. Each compound module should be made from two modules of the background colour and two of different colours from those chosen to form the spirals. Two compound modules of each possible colour combination are required. You can either make up the complete set in advance or put them together as and when they are required during the assembly process.

17

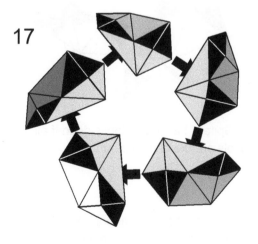

17. Five compound modules go together to form the first spiral pattern like this. All the basic modules forming the arms of the spiral should be the same colour. The basic modules forming the outer edges of the compound modules should all be different colours.

18. Add another compound module to form a three-sided pyramid on each side of the spiral. The colours of these compound modules should match the colours already present at the corners of the spiral. Once the pyramids have been formed the assembly will not lie flat. You may wish to turn the five-pyramid ring upside down and assemble the remainder of the cluster inside a suitably sized transparent mixing bowl. This will help to support the sides until the top is in place.

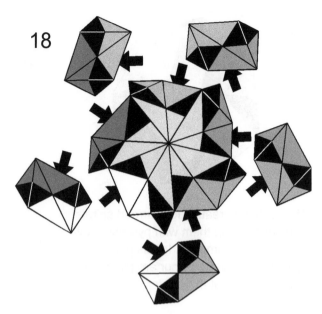

19. Continue creating five-armed spirals and surrounding them with pyramids until the cluster is complete. In this pattern the twin spirals of the same colour are on opposite sides of the cluster.

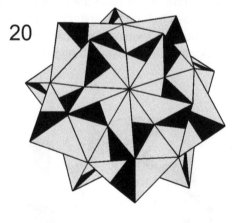

20. Spiral Cluster also looks good if all the spirals are the same colour.

21. You might also choose to abandon the rule that each spiral should be a single colour.

David Mitchell / Paper Crystals

Aurora

I think of Aurora as a crystal composed of star-shaped holes surrounded by hexagonal ones, but it would be equally valid to see it as a kusudama made of star-shaped flowers.

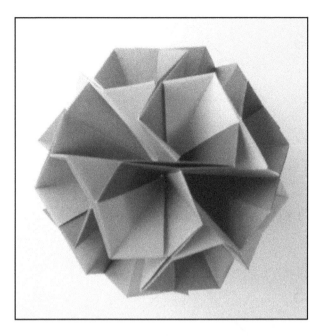

When I first played with this module, in 1989, I found that thirty of them would form a kind of double-walled nolid dodecahedron. A few weeks later I realised that, if the corners of the holes were separated inwards, the pentagons would become stars. Aurora was born.

The late David Petty developed many variations of Aurora, of which the best known are Borealis and Hydra. They are both well worth looking up.

You will need thirty squares of paper. These diagrams show you how to make Aurora using five squares in each of six contrasting but complementary colours.

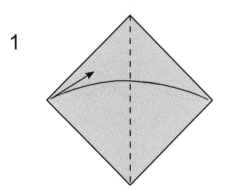

1. Fold in half sideways, then unfold.

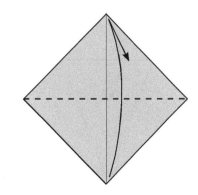

2. Fold in half upwards then unfold.

3

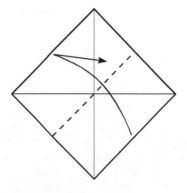

3. Fold in half edge to edge, then unfold.

4

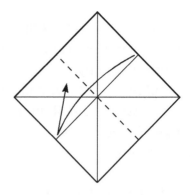

4. Fold in half edge to edge in the opposite direction, then unfold.

5

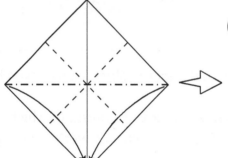

5. Collapse and flatten into the form shown in picture 6.

6

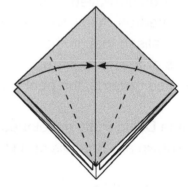

6. Fold both lower sloping edges of the front layers into the centre, making sure the bottom point remains sharp.

7

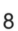

7. Fold the top point downwards along the line of the top edges of the front flaps.

8

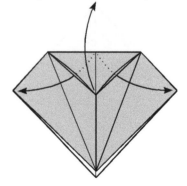

8. Open out the folds made in steps 6 and 7.

David Mitchell / Paper Crystals

9

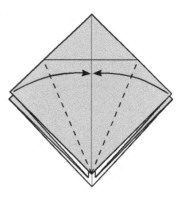

10

9. Turn over sideways.

10. Fold both lower sloping edges of the front layers into the centre, making sure the bottom point remains sharp.

11

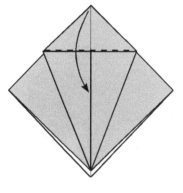

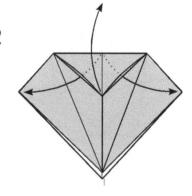

12

11. Fold the top point downwards along the line of the top edges of the front flaps.

12. Open out the folds made in steps 10 and 11.

13

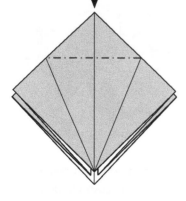

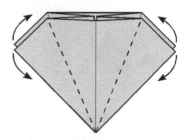

14

13. Turn the top point inside out in between the layers using the existing creases.

14. Configure the module to look like picture 15.

15

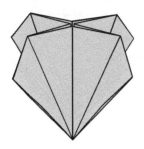

15. Make six in each of five colours.

16

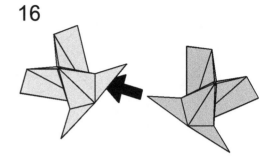

16. Begin by putting two modules of different colours together like this.

17

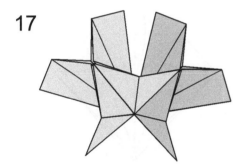

17. Add three more modules of different colours in the same way.

18

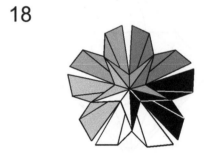

18. The result is a star-shaped hole.

19

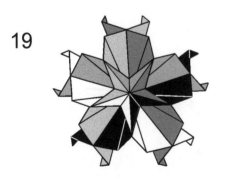

19. Add five more modules to connect the loose arms and create octagonal holes surrounding the central star-shaped hole.

20

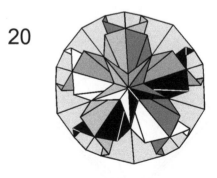

20. Continue to add modules to create further stars and octagons until Aurora is complete. It is also possible to make Aurora in five colours or, of course, using thirty sheets of a single colour or pattern.

David Mitchell / Paper Crystals

Electra

Electra was designed in 1989. It is probably my best known modular design. It was also my first hybrid design and somewhat revolutionary at the time.

The name Electra is, of course, drawn from Greek mythology, but also refers to the similarity of the design to one of those (now outdated) pictures of electrons surrounding a nucleus in their shells.

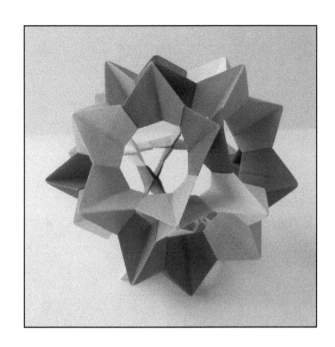

The robust strength of the Electra design comes from the angle at which the pockets are set, which allows the tabs to extend very slightly around the corner between two arms of the module (see picture 22).

You will need thirty squares of paper. These diagrams show you how to make Electra using six squares in each of five contrasting but complementary colours.

1

1. Fold in half diagonally, then unfold.

2

2. Fold in half diagonally in the opposite direction, then unfold.

3

3. Turn over sideways.

4

4. Fold in half sideways, then unfold.

5

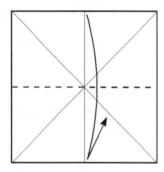

5. Fold in half downwards, then unfold.

6

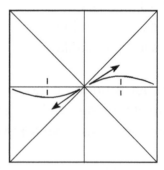

6. Fold both outside edges into the centre, then unfold, but only make two small creases at the centres of the folds.

7

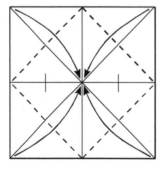

7. Fold all four corners into the centre.

8

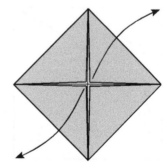

8. Open out the top right and bottom left front flaps.

David Mitchell / Paper Crystals

9

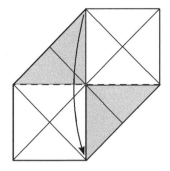

9. Fold in half downwards using the existing crease.

10

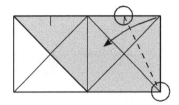

10. Fold the right edge inwards, using one of the short creases made in step 6 to locate the top end of the new crease and making sure the bottom right corner remains sharp.

11

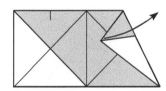

11. Open out the fold made in step 10.

12

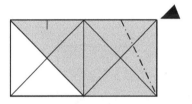

12. Turn the top right corner inside out in between the layers using the creases made in step 10. You will need to reverse the direction of the crease in the front layer.

13

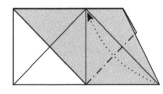

12. Fold the bottom right corner backwards in between the layers using the existing crease.

14

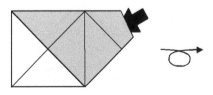

13. This should have created a secure pocket in the position shown. Turn over sideways ...

David Mitchell / Paper Crystals

15

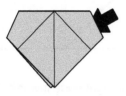

15. ... and repeat folds 10 to 13 on the other half of the paper to create a second secure pocket.

16

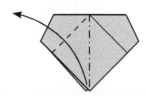

16. Pull the bottom point of the front layer upwards to the left and flatten to look like picture 17.

17

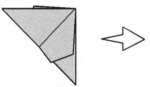

17. Arrange to look like picture 18.

18

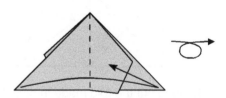

18. Fold the left hand front flap across to the right, then unfold. Turn over sideways.

19

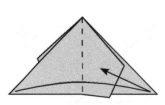

19. Repeat fold 18 on the new left hand front flap then bring both short arms out to the side.

20

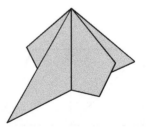

20. The module is finished. You will need thirty in all, six in each of five colours.

David Mitchell / Paper Crystals

21

21. Two modules go together like this.

22

22. Because of the angle of the fold made in step 10 the tip of the tab goes beyond the centre crease and becomes trapped by the central fold of the host module.

23

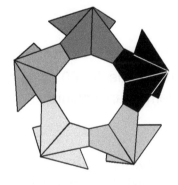

23. Begin assembling Electra by putting five modules together to form a five-sided ring like this.

24

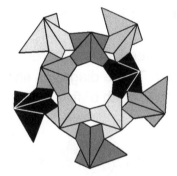

23. Add a further five modules to surround this five-sided ring with three-sided rings, keeping to the colour scheme shown.

25

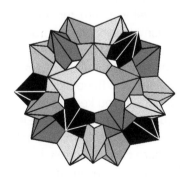

25. Continue adding modules until Electra is complete. The underlying structure of Electra is that of an icosidodecahedron (see page 13). Every five-sided ring is surrounded by three-sided rings and every three-sided ring by five-sided rings. If you keep to this structure as you add the modules the Electra crystal will automatically form. The colour scheme can also easily be extended to the crystal as a whole. Electra also works well when made in a carefully chosen patterned paper.

Electra 60

As the name suggests, Electra 60 is a development of Electra that uses twice as many modules. The module is the same as the module for Electra.

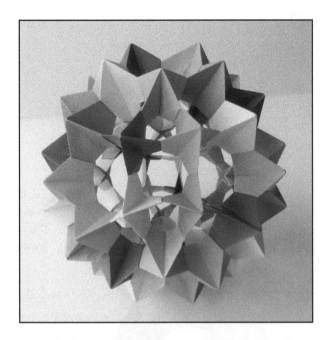

The extra work aside, it is equally easy to fold and assemble, equally robust and at least equally as beautiful as the original, much better known, design.

You will need sixty squares of paper. These diagrams show you how to make Electra 60 using twelve squares in each of five contrasting but complementary colours.

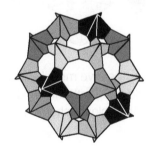

Begin by putting five modules together to form a five-sided ring, then add twelve more modules to surround it with four-sided and three-sided rings in the pattern shown here, keeping to the colour scheme shown.

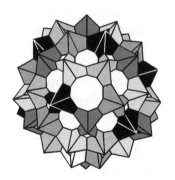

Continue adding modules until Electra 60 is complete. The underlying structure of Electra 60 is that of a rhombicosidodecahedron (see page 13). Every five-sided ring and every three-sided ring are surrounded by four-sided rings. The five-sided and three-sided rings touch at the corners. If you keep to this structure as you add the modules the Electra 60 crystal will automatically form. The colour scheme shown here can also easily be extended to the crystal as a whole. Electra 60 also works well when made in a carefully chosen patterned paper.

David Mitchell / Paper Crystals

Gemini

Gemini was created in 1990 using a simple module developed from the base commonly known as the Preliminary Fold.

There are clear similarities between the forms of Gemini and Electra but the Gemini forms are dimpled rather than pierced and the way that the modules hold together is quite different. The Gemini module will also make a robust twenty-four part assembly which the Electra module will not.

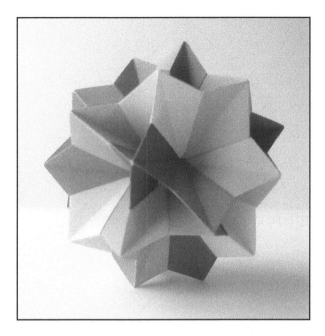

The range of forms that can be made by a Gemini style module can potentially be extended if one of the four arms is folded away inside the module. This would make it possible to create forms based on polyhedra which have three arms meeting at a vertex (rather than four in the case of Gemini), of which there are many. I have provisionally named this variation Trinity, but have not yet found time to investigate whether, and how satisfactorily, the idea works in practice.

The American paperfolder Ravi Apte has explored a similar variation of the Electra module, which I call Triton. His paper on the subject, entitled Universal Vertex Module, can be found in the 2002 Tanteidan Collection (8th issue). The designs in the Triton suite are not as aesthetically pleasing as those of Electra but the range of possible designs is much more extensive.

You will need thirty squares of paper. These diagrams show you how to make Gemini using six squares in each of five contrasting but complementary colours.

1

1. Fold in half diagonally, then unfold.

2

2. Fold in half diagonally in the opposite direction, then unfold.

3

3. Turn over sideways.

4

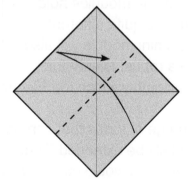

4. Fold in half edge to edge, then unfold.

5

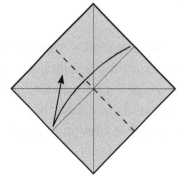

5. Fold in half edge to edge in the opposite direction, then unfold.

6

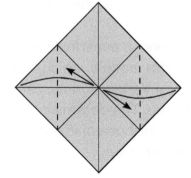

6. Fold both outside corners into the centre, then unfold.

David Mitchell / Paper Crystals

7

7. Turn over sideways.

8

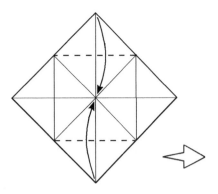

8. Fold the other two corners into the centre.

9

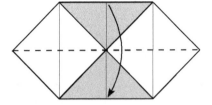

9. Fold in half downwards.

10

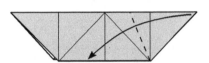

10. Fold the sloping right hand edge onto the bottom edge.

11

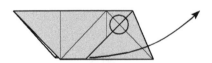

11. Make sure the creases line up at the point marked with a circle. Open out the fold made in step 10.

12

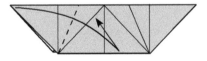

12. Repeat steps 10 and 11 on the left hand half of the paper.

13

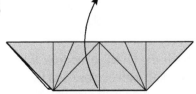

13. Open out the fold made in step 9.

14

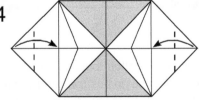

14. Fold both outside corners inwards like this.

15

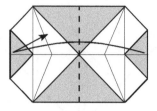

15. Fold in half sideways, then unfold.

16

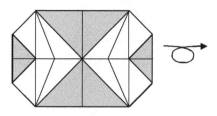

16. Turn over sideways.

17

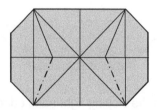

17. Reverse the direction of these two sections of crease so that they become ridges rather than furrows.

18

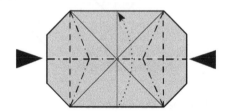

18. Collapse and flatten into the shape shown in picture 19.

19

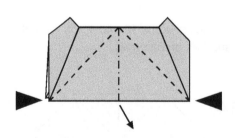

19. Push both bottom outside corners together. As you do this the centre of the front layer will move towards you. The centre of the rear layer will move away from you at the same time.

20

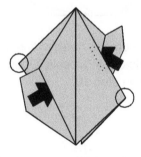

20. This is the finished module. It has two tabs (marked with circles) and two pockets (marked with arrows). You will need six modules in each of five colours.

21

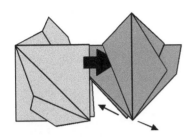

22

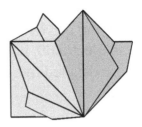

21. The tab of one module goes into the pocket of another like this. You will have to open out the sides of the host module slightly to allow the tab to slide into the pocket easily.

22. When the sides of the host module are closed again the guest module will be locked in place.

23

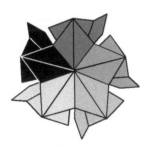

24

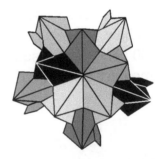

23. Begin assembling Gemini by putting five modules together to form a five-sided ring.

24. Add five more modules to surround the five-sided ring with three-sided rings, keeping to the colour scheme shown.

25

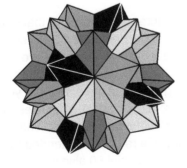

25. Continue adding modules until Gemini is complete. The underlying structure of Gemini is that of an icosidodecahedron (see page 13). Every five-sided ring is surrounded by three-sided rings and every three-sided ring by five-sided rings. If you keep to this structure as you add the modules the Gemini crystal will automatically form. The colour scheme shown here can be extended to the crystal as a whole. Gemini 30 also works well when made in a carefully chosen patterned paper.

Gemini 60

Gemini 60 is based on the same underlying polyhedral structure as Electra 60, but the faces are dimpled rather than pierced.

The module for Gemini 60 is the same as the module for Gemini and they are put together in exactly the same way.

You will need sixty squares of paper. These diagrams show you how to make Gemini 60 using twelve squares in each of five contrasting but complementary colours.

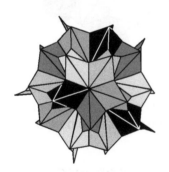

Begin by putting five modules of different colours together to form a five-sided ring, then adding twelve more modules to surround this first ring with four-sided and three-sided rings in the pattern shown here and keeping to the colour scheme shown.

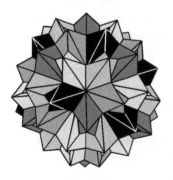

The underlying structure of Gemini 60 is that of a rhombicosidodecahedron (see page 13). Every five-sided ring and every three-sided ring are surrounded by four-sided rings. The five-sided and three-sided rings touch at the corners. If you keep to this structure as you add the modules the Gemini 60 crystal will automatically form. The colour scheme shown here can be extended to the crystal as a whole. Gemini 60 also works well when made in a carefully chosen patterned paper.

David Mitchell / Paper Crystals

Gemini 24

Gemini 24 can be made
with the module that was
used to make Gemini and
Gemini 60 but the result is
better if the angle at which
the pocket is set is widened
slightly. The method
explained here is slightly
different from the method
given in the first edition.
Either method gives an
equally good result.

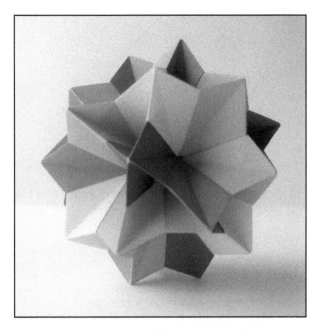

You will need twenty-four
squares of paper. These
diagrams show you how to make Gemini 24 using six squares in each of
four contrasting but complementary colours.

Begin by following steps 1 to 7 of Gemini (see pages 48 and 49).

8

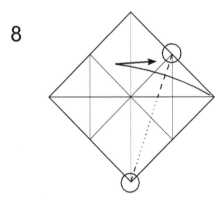

9

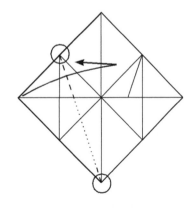

8. Make a fold along a line between the middle of the top right sloping edge and the bottom point but only crease the part marked with a forwards fold line.

9. Repeat step 8 on the left half of the paper

10

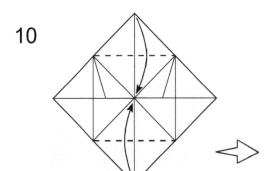
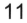

11

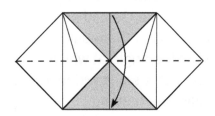

10. Fold the top and bottom corners into the centre.

11. Fold in half downwards using the existing crease.

12

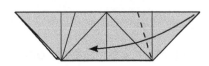

13

12. Fold the top right corner inwards using the existing crease.

13. Open out the fold made in step 12.

14

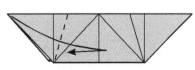

15

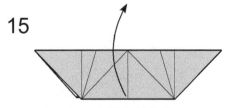

14. Repeat folds 12 and 13 on the left side of the paper.

15. Open out upwards and continue with steps 14 to 19 of Gemini (see pages 49 and 50).

20

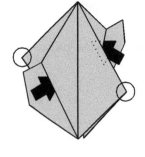

20. This is the finished module. It has two tabs (marked with circles) and two pockets (marked with arrows). You will need six modules in each of four colours.

David Mitchell / Paper Crystals

21

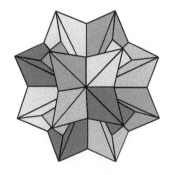

21. The front half of Gemini 24 is built of four-sided and three sided rings, arranged like this.

22

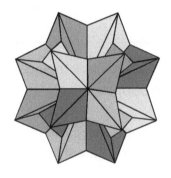

22. The back half looks exactly the same, except that the pattern of the colours is reversed.

22

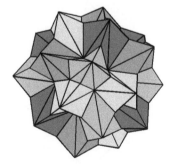

22. When finished Gemini 24 should look like this. It is possibly the most attractive of the Gemini forms.

Gemini 12

This design completes the Gemini suite. In order to create a design based on the cuboctahedron it is necessary to widen the angles at which the pockets are set.

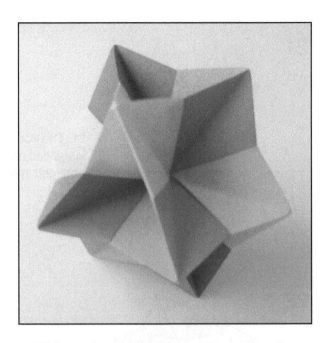

It is possible to make an Electra 12 design in an essentially similar way. However, in the case of Electra, widening the angle also has the effect that folding the excess paper inwards (see picture 13 on page 43) is no longer sufficient to secure the pockets and a more complex strategy must be adopted.

You will need twelve squares of paper. These diagrams show you how to make Gemini 12 using four sheets in each of three contrasting but complementary colours.

Begin by following steps 1 to 7 of Gemini (see pages 48 and 49).

8

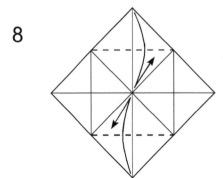

9

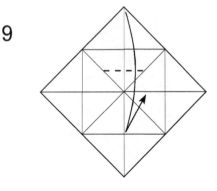

8. Fold the top and bottom corners into the centre, then unfold.

9. Fold the top corner inwards like this, then unfold, but only flatten the central section of the crease.

David Mitchell / Paper Crystals

10

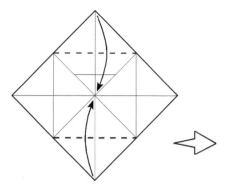

10. Fold the top and bottom corners inwards using the existing creases.

11

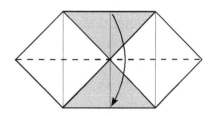

11. Fold in half downwards using the existing crease.

12

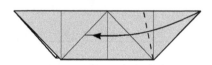

12. Fold the right corner onto the crease made in step 9, making sure the crease intersects the bottom right corner.

13

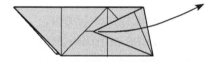

13. Open out the fold made in step 12.

14

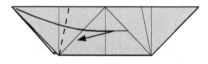

14. Repeat steps 12 and 13 on the left half of the paper

15

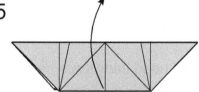

15. Open out upwards and continue with steps 14 to 19 of Gemini 30 (see pages 49 and 50). Make four modules in each of three colours.

20

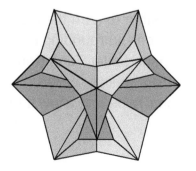

20. Gemini 12 is made by surrounding three-sided rings by four-sided rings (or vice versa if you prefer) like this.

Proteus

Proteus, designed in 1992, is one of my all time favourite modular designs and is almost certainly the one I have made most often to give to friends as a gift. It is made from thirty identical modules using 60 degree folding geometry (the only such design in this book) and is based on the polyhedron known as the icosidodecahedron (see page 13), which has twenty triangular faces surrounding twelve pentagonal ones. In the Proteus design the pentagonal faces are sunken and pierced, which gives the design its interest and beauty. The original method of folding the modules, which is the one diagrammed here, leaves a small part of the white side of the paper visible on the inside surface of the crystal. It is a simple matter to design a module that overcomes this fault, if fault it is, but the resulting module is somewhat less efficient in its use of paper.

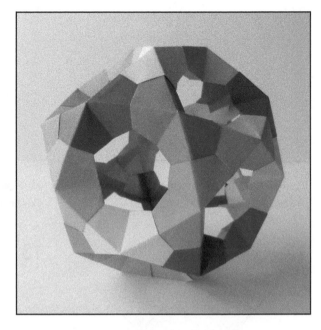

You will need thirty squares of paper. The diagrams show you how to make Proteus using six squares in each of five colours, but Proteus also works well when made from a carefully chosen patterned paper or many types of patterned paper combined in a patchwork effect.

Twelve modules of the same design will go together to form the much smaller Proteus 12 which has eight triangular faces surrounding six sunken and pierced square ones. The British paperfolder Tung Ken Lam has independently produced an essentially similar design, called Jitterbug, which he has enhanced with additional folds that allow it to twist and collapse in two separate directions.

1

1. Fold in half sideways, then unfold.

2

2. Fold both outside edges into the centre, then unfold just the right hand flap.

3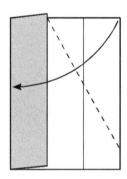

3. Fold the top right corner onto the left hand edge, making sure that the crease begins at the top of the vertical crease made in step 1.

4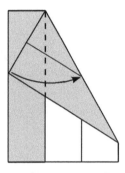

4. Fold the front flap in half sideways like this.

5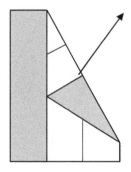

5. Open out the folds made in steps 3 and 4.

6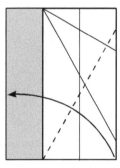

6. Fold the bottom right corner onto the left hand edge, making sure that the crease begins at the foot of the vertical crease made in step 1.

7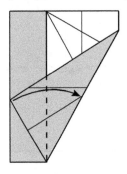

7. Fold the front flap in half sideways like this.

8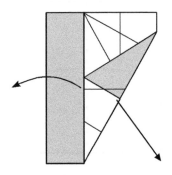

8. Open out completely.

9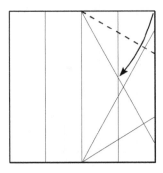

9. Fold the right hand half of the top edge onto the sloping crease.

10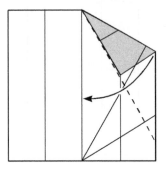

10. Fold the top right corner inwards using the existing crease.

11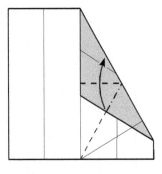

11. Make this fold by reversing the direction of the existing crease. As you do this the bottom right hand corner will swivel inwards.

12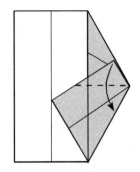

12. Flatten the paper to look like this then fold the top corner of the front layer downwards using the existing crease.

David Mitchell / Paper Crystals

13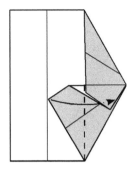

13. Fold the left hand half of the middle layers to the right underneath the front layer so that a pocket is formed.

14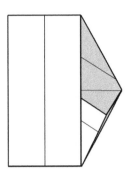

14. Check that the pocket is secure before moving on.

15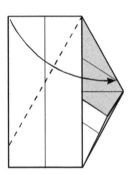

15. Fold the left hand half of the top edge onto the sloping top right hand edge.

16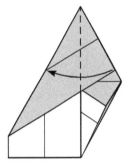

16. Fold the front flap in half sideways like this.

17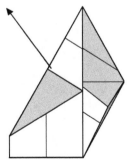

17. Open out the folds made in steps 15 and 16.

18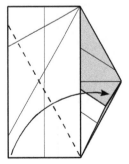

18. Fold the left hand half of the bottom edge onto the sloping bottom right hand edge.

19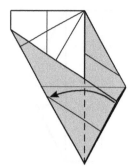

20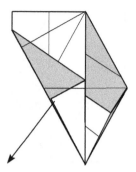

19. Fold the front flap in half sideways like this.

20. Open out the folds made in steps 18 and 19.

21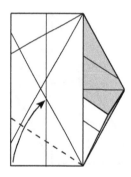

22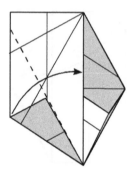

21. Fold the bottom left corner inwards using the existing crease.

22. Fold the bottom left corner inwards again using the existing crease.

23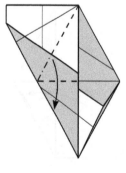

24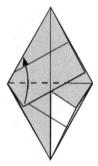

23. Make this fold by reversing the direction of the existing crease. As you do this the top left corner will swivel inwards.

24. Flatten the paper to look like this then fold the bottom corner of the front flap upwards using the existing crease.

25

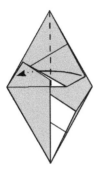

25. Fold the middle layers in half sideways underneath the front flap to form a pocket.

26

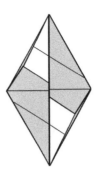

26. Make sure the pocket is secure before moving on.

27

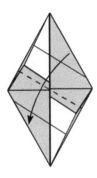

27. Fold in half diagonally downwards, making sure that the crease passes through the centre point.

28

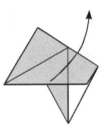

28. The left and right sloping edges should be aligned. Crease firmly, then unfold.

29

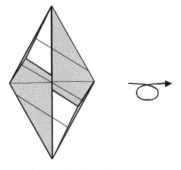

29. Turn over sideways.

30

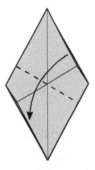

30. Fold in half diagonally downwards, making sure that the crease passes through the centre point.

31

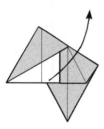

31. The left and right sloping edges should be aligned. Crease firmly, then unfold.

32

32. Collapse the module into shape using the existing creases.

33

33. The module has two tabs (marked by circles) and two pockets (marked by arrows). You will need thirty modules, six in each of five colours.

34

34. Three modules go together like this to form a triangular face.

35

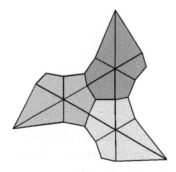

35. Gently ease the modules together until all the edges of the central triangle are aligned accurately.

36

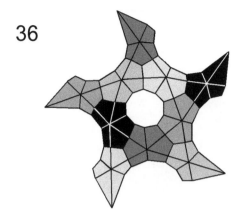

37

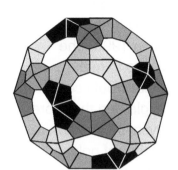

36. Add seven more modules to form five triangular faces surrounding a pentagonal hole, while keeping to the colour scheme shown.

37. Add further modules to turn each of the open edges into another pentagonal hole. Keep on doing this until Proteus is complete

Proteus 12

You will need twelve squares of paper. These diagrams show you how to make Proteus 12 using six squares in each of four complementary but contrasting colours.

38

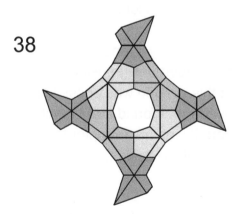

39

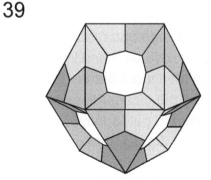

38. Begin by putting eight modules together like this to create four triangular faces surrounding a square hole, while keeping to the colour scheme shown.

39. Add further modules to turn each of outside edges into another square hole. Keep on doing this until Proteus 12 is complete. Proteus 12 is more difficult to assemble than Proteus.

Zigzag

The first edition of this book included a design called Sappho which I had designed in 1999. The concept was to make a module that would collapse to any angle and therefore make crystals based on a large number of polyhedral forms. This was an interesting idea but it didn't work out so well in practice. Many of the theoretically possible designs proved to be unstable or simply impossible to construct. This was partly because the flexibility built into the modules allowed them to twist and collapse in unforeseen ways and partly because the modules started to interfere with each other when collapsed to an angle of less than about sixty degrees. The modules did however work well for a design based on the icosahedron (see page 13) and it was that design that was included in the first edition.

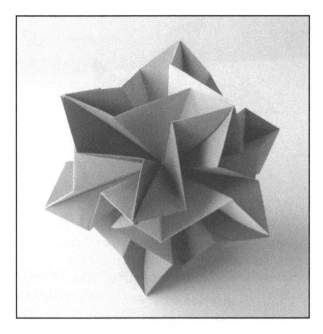

When I was preparing this new edition I decided to try to improve the Sappho design and made up an icosahedron-based design using a simplified module. I had known in 1999 that this version was possible but had not tried it out before. The result surprised me. I found that I much preferred the cleaner lines of the new version. It was also simpler to fold and easier to put together. And so it is this simplified design, now christened Zigzag, that is included here.

You will need thirty squares of paper. These diagrams show you how to make Zigzag using six squares in each of five contrasting but complementary colours.

1

1. Fold in half downwards, then unfold.

2

2. Fold the top right and bottom left corners into the centre.

3

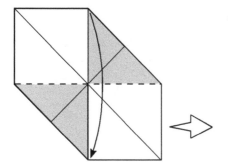

4. Fold in half downwards, using the existing crease.

4

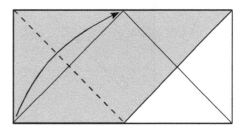

4. Fold the left hand edge onto the top edge.

5

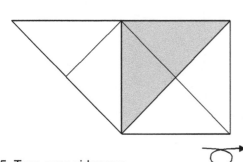

5. Turn over sideways.

6

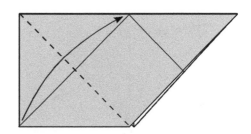

6. Fold the new left edge onto the top edge.

7

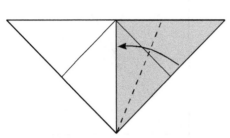

7. Fold the sloping right edge inwards to lie against the upright edge of the front flap.

8

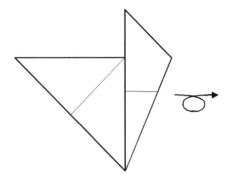

8. Turn over sideways.

9

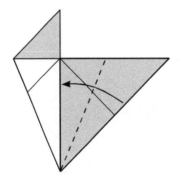

9. Fold the new sloping right edge inwards to lie against the upright edge of the front flap.

10

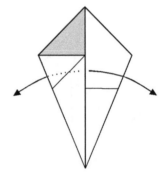

10. Open out the folds made in steps 7 and 9 but do not flatten the creases.

11

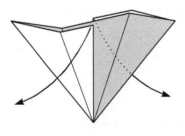

11. Open out the front and rear flaps but do not flatten the creases.

12

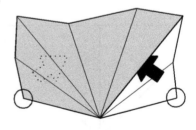

12. This is the Zigzag module. The tabs are marked by circles and the pockets by arrows.

13

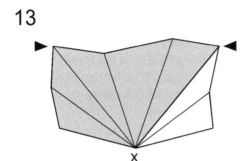

x

13. The angle at x can be changed by pushing the top corners together. You will need thirty modules, six in each of five colours.

14

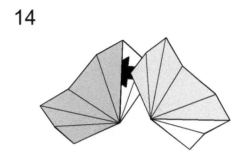

14. Two modules go together like this. The tab of the right hand module is inserted into the pocket of the left.

15

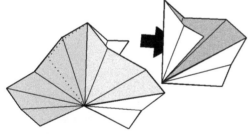

15. A third module can be added like this to create a ring of three.

16

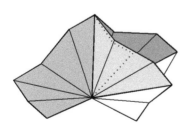

16. The ring can be closed by inserting the tab of the third module (indicated by a dotted line) inside the first. Rings of any number of modules are possible.

17

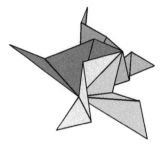

17. Begin assembling Zigzag by putting together a ring of five modules of five different colours like this. This creates one corner of the design. Each of the twenty corners of the design will be formed from a ring of five modules of five different colours in the same way.

18

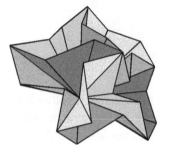

18. Add five more modules to link the free ends of the first five modules together, taking care to keep to the colour scheme shown. This creates five more corners.

19

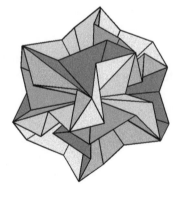

19. Add two more modules to complete each of these five new corners, keeping to the colour scheme shown. Continue to add modules to form, link and complete new corners until Zigzag is complete.

Zigzag 36

Zigzag 36 was designed in 2011 during the preparation of this second edition. It is an unusual design based around the structure of the nolid cube (see picture below). The nolid cube structure itself is unstable but stability can be achieved by filling the open faces with extra modules.

The module for Zigzag 36 is the same as the module for Zigzag (see pages 67 & 68).

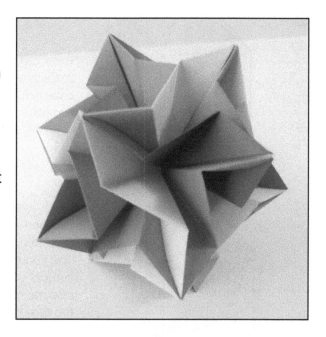

You will need thirty-six square sheets of paper. These diagrams show you how to make Zigzag from twelve squares in one base colour and eight in each of three other contrasting but complementary colours. Because the appearance of Zigzag 36 is quite confusing these assembly instructions have been drawn using simplified diagrams.

Begin by making all thirty-six modules.

1

1. The structure of Zigzag 36 is based on a nolid cube like this. The twelve base colour modules are arranged like this within the overall structure of Zigzag 36.

2

2. Each of the eight open faces of the nolid cube is filled with four modules, two in each of two different colours, arranged like this.

3

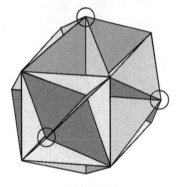

3. When all the eight open faces have been filled with modules the design will look like this. The corners marked with circles are the corners where four modules, two in each of two colours, meet. There are six corners like this in the design.

4

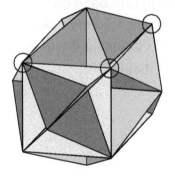

4. In this picture the corners marked with circles are those where six modules, three in the base colour and one in each of the other three colours, meet. There are eight corners like this in the design.

5

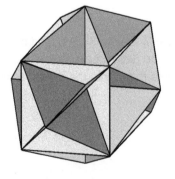

5. It is probably easiest to begin assembling Zigzag 36 by putting four modules, two in each of two colours together to form a corner and then linking their free ends together with four base colour modules. The next step is to finish one of the corners where six modules meet. At that point you will have established the pattern and the rest is relatively easy. The result should look like the photo on the previous page.

David Mitchell / Paper Crystals

Gaia

Gaia is one of my favourite modular designs. It ticks all the boxes. It is visually fascinating when finished (so that you never get tired of looking at it), has windows that allow light to penetrate into and through the design, is made from only six modules (so you don't have to set up a production line) and the modules themselves are interesting and elegant to fold. As a bonus it is also a fine example of a design that

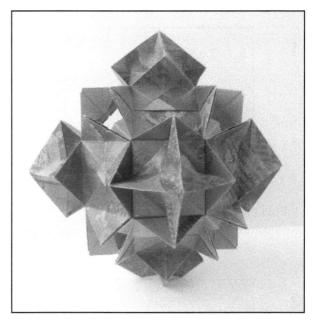

continues to develop after the modules have been assembled.

Gaia was created in 1989 as a result of the same technical exploration of the possibilities inherent in the base pictured in step 36 that produced the Enigma Cube. In the assembly method shown here the six modules first go together to form an eight-pointed star but it is also possible to alter the configuration of the modules so that they go together to form a cube instead. I have not drawn diagrams for this possibility but you might like to experiment with it and see which method you prefer. Both methods lead to the same final form.

Gaia was designed as a hanging ornament but it is possible to turn one of the points into a base, which would allow it to sit on a shelf, by turning the tip inwards. The photo above shows what the result of doing this would look like.

You will need six squares of paper for the design and one more of the same size to use as a template. The diagrams show you how to fold Gaia using two squares in each of three plain colours but I find that the best results are obtained using patterned paper.

Folding the 3x3 grid

1

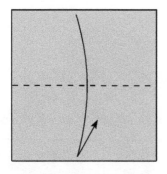

1. Fold the template square in half downwards, then unfold.

2

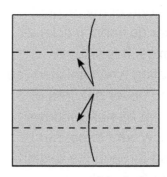

2. Fold both the top and bottom edges to the centre, then unfold.

3

3. The template is finished.

4

4. Lay your second square in front of the template like this. Make sure the two top corners are aligned accurately in the way shown here.

5

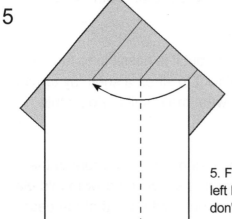

5. Fold the right hand edge across to the left like this. Make sure the two squares don't slip out of alignment as you do this.

David Mitchell / Paper Crystals

6

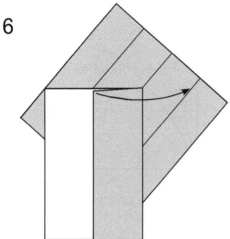

6. Open out the fold made in step 5 and remove the square from the template.

7

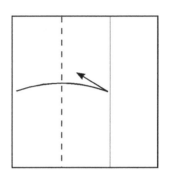

7. Fold the left hand edge onto the crease made in step 5, then unfold. Your paper is now divided into thirds in one direction.

8

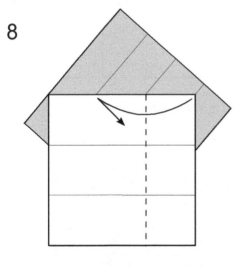

8. To divide the paper into thirds in the other direction as well simply rotate it through ninety degrees and place it back on the template. Fold the right hand edge across to the left like this, then unfold.

9

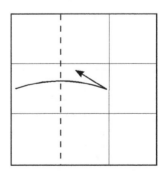

9. Remove the paper from the template, fold the left edge onto the crease made in step 8, then unfold.

Folding the modules

10

10. Your paper is now divided into a 3x3 grid of smaller squares.

11

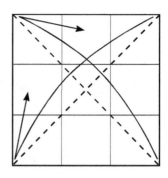

11. Fold in half diagonally in both directions, then unfold.

12

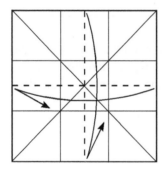

12. Fold in half edge to edge in both directions, then unfold.

13

13. Turn over sideways.

14

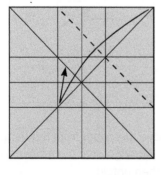

14. Fold the top right corner inwards like this, then unfold.

15

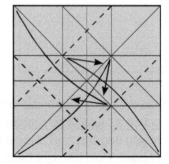

15. Repeat step 14 on the other three corners.

David Mitchell / Paper Crystals

16

16. Turn over sideways.

17

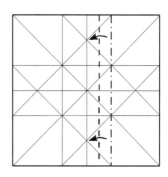

17. Pleat the paper to make the new crease shown here.

18

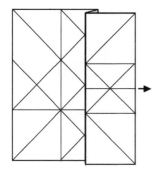

18. Open the pleat out again.

19

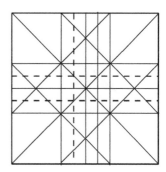

19. Add these three creases in a similar way.

20

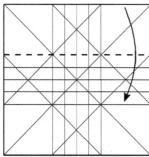

20. Fold the top third of the paper downwards.

21

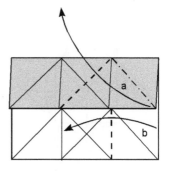

21. Make fold a then fold b using the existing creases so that your paper looks like picture 22.

22

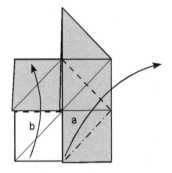

22. Make fold a then fold b using the existing creases.

23

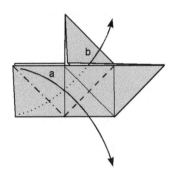

23. Make fold a then fold b using the existing creases.

24

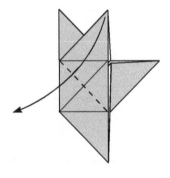

24. Fold the top corner of the front flap downwards to the left.

25

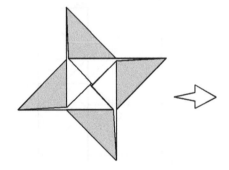

25. This form is known as the Pinwheel. The next picture is on a larger scale.

26

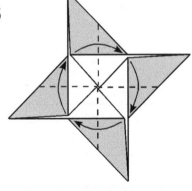

26. Take the right hand arm of the Pinwheel and fold it in half downwards in the way shown. This fold is made through all the layers of the arm. Repeat this fold on the other three arms working anticlockwise around the design. The paper will not lie flat until you have completed all four folds. Flatten and crease firmly so that your paper now looks like picture 27.

27

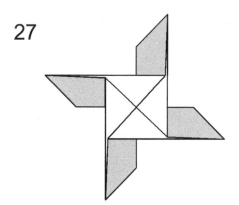

27. Lift the top arm upwards and towards you so that it looks like picture 28.

28

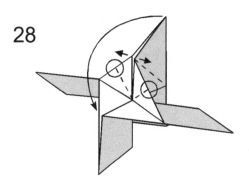

28. Open the centre of this arm then squash it flat. The centres of the two flaps marked with circles fold away from you to allow this to happen.

29

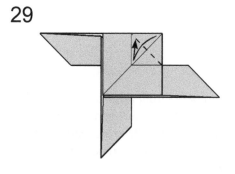

29. Fold the top right hand corner inwards like this, then unfold.

30

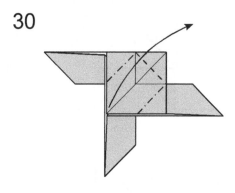

30. Fold the front flap diagonally to the right and flatten symmetrically. The two creases marked with dashed and dotted backwards fold lines will form as you flatten the fold.

31

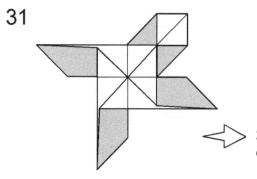

22. Repeat steps 28 to 30 on each of the other three arms in turn.

32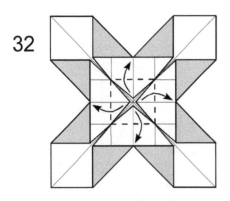

33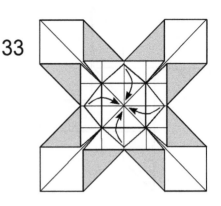

32. Fold all four centre points outwards as far as they will go.

33. Open out the folds made in step 32.

34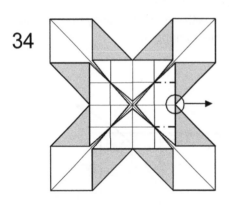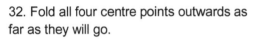

34. Take hold of the front layer at the point marked with a circle and pull gently to the right. Flatten symmetrically to look like picture 35. All the creases you need to do this are already there.

35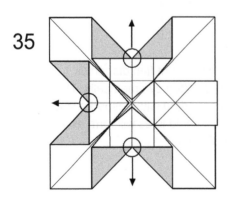

36

35. Repeat step 34 on each of the other three edges in turn.

36. This is the Enigma Base. Turn over sideways.

David Mitchell / Paper Crystals

37

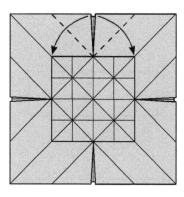

37. Make the two small folds shown then flatten the underlying layers so that the result looks like picture 38.

38

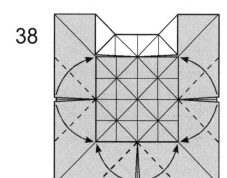

38. Repeat step 37 on the other three edges.

39

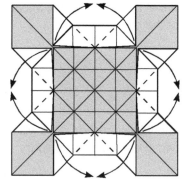

39. Fold all eight triangular flaps back into their original positions.

40

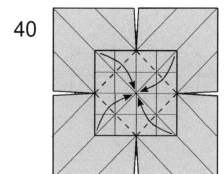

40. Fold all four corners of the central square into the centre. Crease firmly.

41

41. Turn over sideways.

42

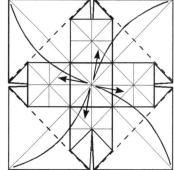

42. Fold all four corners to the centre, then unfold.

43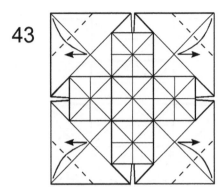

44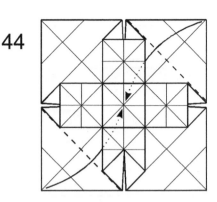

43. Fold all four corners inwards like this, then unfold.

44. Fold two opposite corners inwards using the creases made in step 42 but this time tuck them into the pockets underneath the front layers. Make sure the points of the flaps go right into the points of the pockets.

45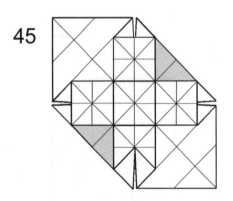

45. The Gaia module is finished. You will need six modules, two in each of three colours.

Assembling the modules

46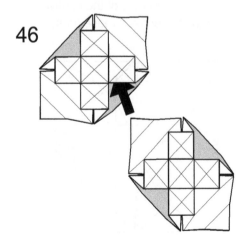

47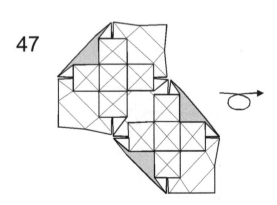

46. Two modules go together like this.

47. Turn over sideways.

48

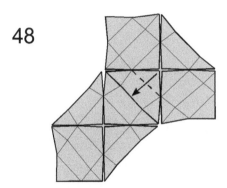

48. The modules can be locked together by folding back this flap. Now you understand how this works take the modules apart again.

49

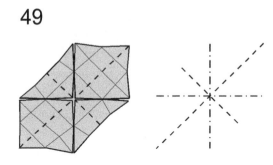

49. Apply this crease pattern to each module and configure it into the form shown in picture 50 Set the creases in by squashing the fold flat both ways, then allow the natural spring in the creases to open out the module into a three-dimensional form.

50

50. This is a simplified drawing showing what the modules should look like once they have been configured.

51

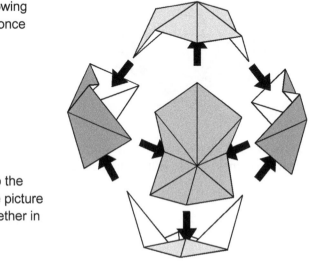

51. Combine the six modules into the form of an eight-pointed star (see picture 52) like this. The modules go together in the way shown in picture 46.

Altering the form

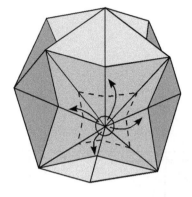

52

52. Find one of the six points where the valleys between the points of the star meet and open up the four triangular flaps at right angles or slightly beyond. As you do this the point between them will flatten and become the centre of a small square face.

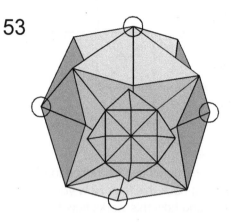

53

53. Repeat step 52 on the five other similar corners (four of which are marked with circles here). The design will change shape entirely as you do this (to a shape based on the mathematical form known as a rhombicuboctahedron). This process also serves to lock the modules together.

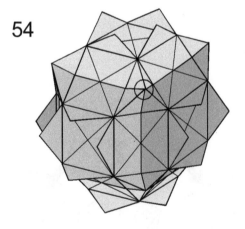

54

54. Now open up the three flaps which form the corner marked with a circle here.

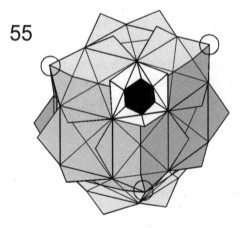

55

55. You have opened a window into the interior of the Gaia assembly. There are seven other identical corners to open up. Three of these corners are marked with circles here.

56

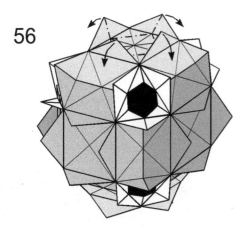

56. Put a finger inside the design and push the top square face gently upwards. Spread the flaps surrounding this square outwards. As the layers open up pinch each corner together in turn to create the shape shown in picture 57.

57

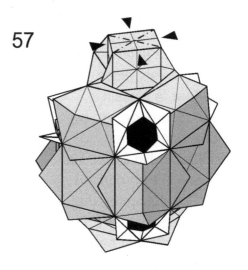

57. Press the centres of the sides of the top square face together so that the centre of the square rises and becomes a point.

58

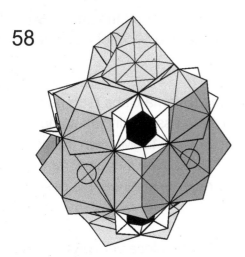

58. Repeat steps 56 and 57 on the five other similar faces, two of which are marked with circles here.

59

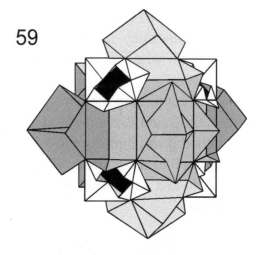

59. Gaia is finished. Arrange the free standing flaps to taste. To hang Gaia tie a small bead onto a piece of cotton and use a needle to thread it through the centre of one of the points from the inside out. To make Gaia stand create a base by inverting one of the points. You can do this by allowing the centre of the top square face to sink while following instruction 57.

Omega 12

Omega 12 is a twelve-piece version of the six-piece Omega Star, a classic modular origami design by the Hong Kong based paperfolder Philip Shen. His design was in turn derived from XYZ, a design by the American paperfolder E.D. Sullivan, which was named for the three planes of standard spatial geometry.

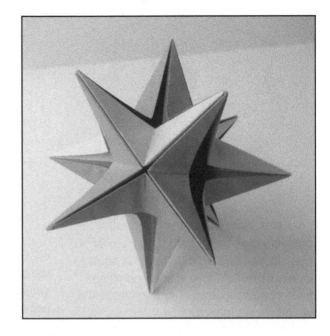

Omega 12 uses twice as many modules, but as a result it is a more versatile design. This same modular method has also been independently discovered by Robert Neale and Michael Naughton. I do not know who has priority.

It is worth comparing the Omega Star with the Enigma Cube (see pages 91 to 105). David Brill's method for Enigma 12 is essentially the same as the method given here for the XYZ base for Omega 12. My own method for Enigma 6 bears a close relationship to E.D. Sullivan's original method for XYZ. In fact you should easily be able to reverse engineer his design from mine.

XYZ can be developed in many other ways. Single piece versions of XYZ (and consequently the Omega Star) have also been designed, though the distribution of paper throughout the designs is necessarily less even.

You will need twelve squares of paper. The diagrams show you how to make Omega 12 using three modules in each of four contrasting but complementary colours. You can also make it from three squares in each of four colours (which is the colour scheme for the original XYZ). My personal preference is for the four colour version.

1

1. Fold in half from right to left, then unfold.

2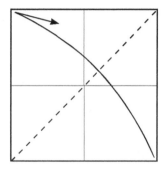

2. Fold in half downwards, then unfold.

3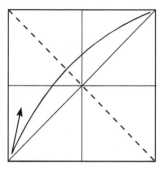

3. Turn over sideways.

4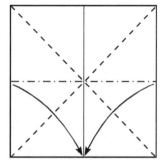

4. Fold in half diagonally, then unfold.

5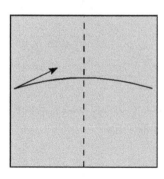

5. Fold in half diagonally in the opposite direction, then unfold.

6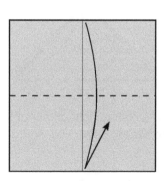

6. Collapse into the shape shown in picture 7.

7

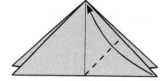

7. Fold the bottom right corner of the front flap onto the top point.

8

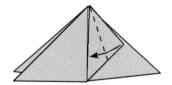

8. Fold the resulting front flap in half sideways like this.

9

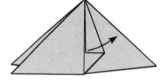

9. Open out the folds made in steps 7 and 8.

10

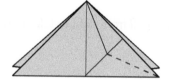

10. Reverse the direction of this section of crease so that it changes from a ridge to a furrow.

11

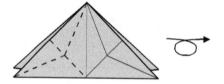

11. Repeat steps 7 to 10 on the front left hand flap, then turn over sideways.

12

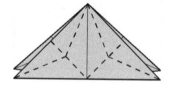

12. Repeat steps 7 to 11 on the other half of the paper.

13

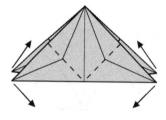

13. Fold the ends of all four flaps outwards at right angles.

14

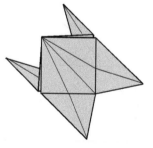

14. The module is finished. Make four in each of three colours.

David Mitchell / Paper Crystals

15

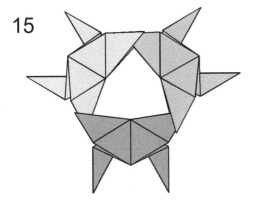

15. Put three modules together like this to form a sunken three-sided corner.

16

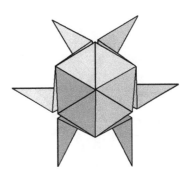

16. Add further modules to form other sunken corners, keeping to the colour scheme shown in picture 17.

17

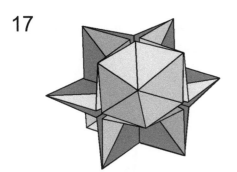

17. This is the XYZ form. This design could be called XYZ 12.

18

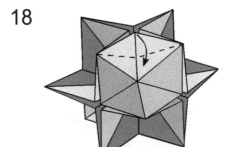

18. Fold the top edges of the sunken corner inwards to create a collar, using the existing creases.

19

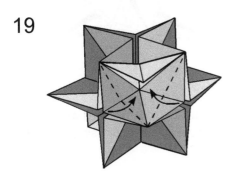

19. Fold the other edges inwards in the same way.

20

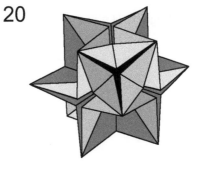

20. Do the same thing to all the edges of all the other sunken corners.

21

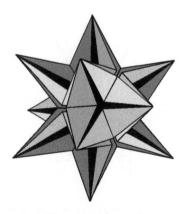

21. This is the result. Omega 12 is finished. If the quality of your paper will allow you to you can work the collars into smooth curves.

22

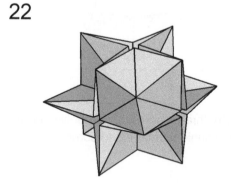

22. When made in just three colours XYZ looks like this ...

23

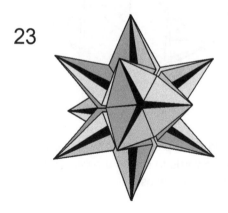

23. ... and Omega 12 like this.

24

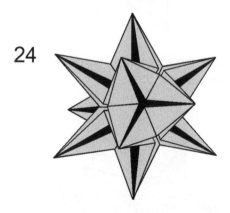

24. Omega 12 also works well when made in a single colour or using patterned paper.

Enigma

Enigma, also known as the Enigma Cube, is a cube surrounded by curved collars. It is a good example of a form that was originated through, and is unique to, modular origami.

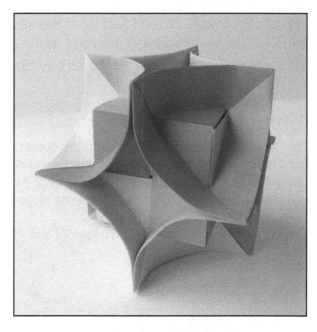

The original Enigma Cube, called Enigma 2 in this book, was created in 1988, when I was exploring the potential of a base which I had developed from a 3x3 grid (see picture 36 on page 80). I now call this base the Enigma Base after the Enigma design. The same base also yielded Gaia (see pages 73 to 85) and several attractive bowls. The folding sequence by which this base is arrived at is perhaps the most interesting in the whole of origami and I never tire of folding it.

I am still fond of this original version of Enigma. I particularly like the way the form develops so unexpectedly after the modules have initially been assembled into such an uninspiring shape. Because of the number of creases that cross the curved collars it is however difficult to get a good result from ordinary paper, and I would recommend using paper that has been backcoated with foil.

Later that same year I sent my Enigma 2 design to Wayne Brown, who sent it to David Brill, who was unable to fold it from my rough diagrams but nevertheless returned it to me wonderfully improved. The version that came back to me, included here as Enigma 12, was made from twelve modules developed from waterbomb bases. The curves of the collars were now beautifully smooth, the modular method allowed for a much more attractive colour scheme, and the distribution of paper throughout the design had been evened out.

My somewhat competitive response to Enigma 12 was to immediately design Enigma 6, which I feel is, in the version included here, where the form continues to develop after the modules have been assembled, the best of the three. But then, I would say that, wouldn't I?

Enigma 2

You will need two squares of paper for the design and another of the same size to use as a template. The diagrams show these two squares in different tones of grey but you will get a better result if you use two squares of the same colour and pattern. It is easier to create and maintain the curves if you use paper that has been backcoated with foil.

Begin by following steps 1 to 9 on pages 74 and 75 to crease your squares into a 3x3 grid.

1

1. Fold all four corners into the centre, then unfold.

2

2. Follow steps 11 to 35 of Gaia on pages 76 to 80 to fold your paper into an Enigma Base.

3

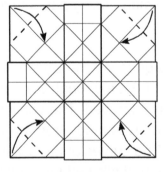

3. Fold all four corners inwards like this.

4

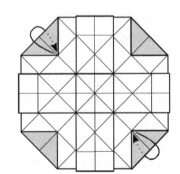

4. Fold the top left and bottom right front flaps backwards out of sight by reversing the direction of the existing creases.

David Mitchell / Paper Crystals

5

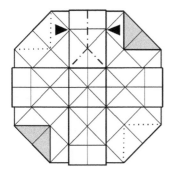

5. Push the edges of one of the four arms of the front layers together so that the centre of the arm rises towards you.

6

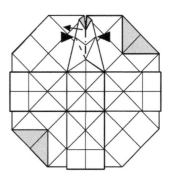

6. When you get to this stage push the central front flap across to the left.

7

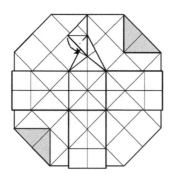

7. Tuck the front flap away behind the other layers of the arm.

8

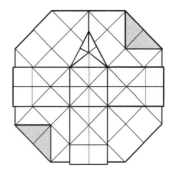

8. You should have created a small three sided pyramid like this. This was just practice. Open the arm out again.

9

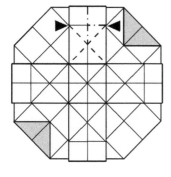

9. Repeat the same process but this time allow the centre of the arm to sink away from you. This is difficult but not impossible.

10

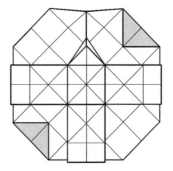

10. The result will be a neat sunken pyramid like this.

11

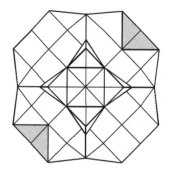

11. Repeat this move on all four arms.

12

12. The centre of your paper should now look like this.

13

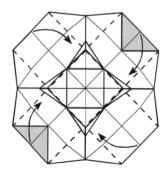

13. Lift the edges of the paper upright at right angles so that the result looks like picture 14.

14

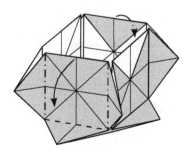

14. Fold the front and back sides of the cube downwards again.

15

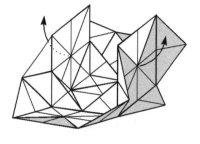

15. Lift these two small flaps upwards at right angles.

16

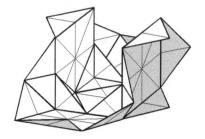

16. Fold both modules to this stage.

David Mitchell / Paper Crystals

17

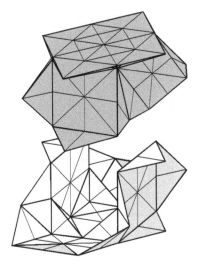

17. Turn one module upside down and rotate it through ninety degrees. Lower the top module until they nest gently together.

18

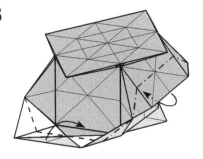

18. Fold the outside edges of both modules inwards like this. Make sure that you trap the corner flaps of the other module inside the folds as you do this. There are two other outside edges behind the design. These must also be folded inwards in the same way.

19

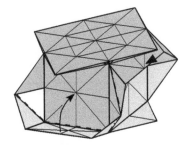

19. Fold the outside edges inwards again to link the modules firmly together.

20

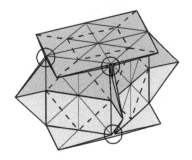

20. Open up all eight corners of the cube (three are marked with circles here) to reveal the collars. Smooth the collars into gentle curves.

21

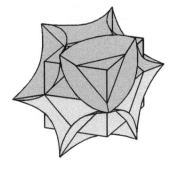

21. Your finished Enigma Cube should look like this (except that both your modules should be the same colour and pattern).

Enigma 6

You will need six squares of paper. These diagrams show you how to make Enigma 6 using two squares in each of three contrasting but complementary colours.

1
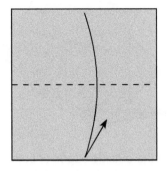

1. Fold in half downwards, then unfold.

2
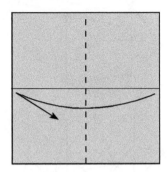

2. Fold in half sideways, then unfold.

3

3. Turn over sideways.

4
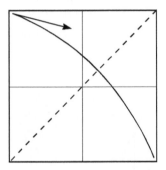

4. Fold in half diagonally, then unfold.

5
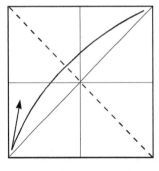

5. Fold in half diagonally in the opposite direction, then unfold.

6
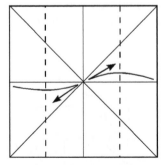

6. Fold both outside edges into the centre, then unfold.

David Mitchell / Paper Crystals

7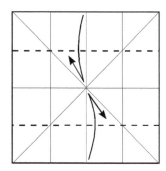

7. Fold the top and bottom edges into the centre, then unfold.

8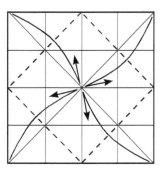

8. Fold all four corners into the centre, then unfold.

9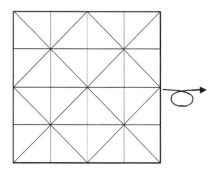

9. Turn over sideways.

10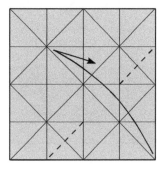

10. Fold the bottom right corner inwards like this, then unfold. Be careful not to crease the paper all the way across the fold.

11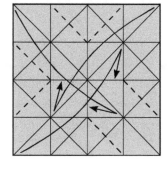

11. Repeat fold 10 on the other three corners.

12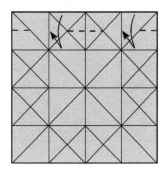

12. Fold the top edge inwards like this, then unfold. Be careful not to crease the paper all the way across the fold.

13

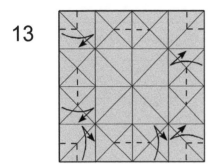

13. Repeat step 12 on the other three edges.

14

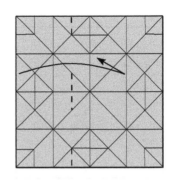

14. Fold the left edge inwards like this, then unfold. Be careful not to crease the paper all the way across the fold.

15

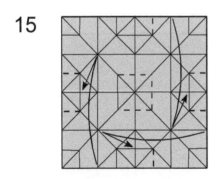

15. Repeat step 14 on the other three edges.

16

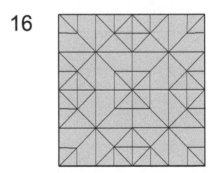

16. Check that all these creases are present before moving on.

17

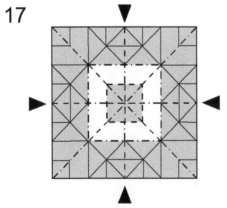

17. Collapse the module like this. The white area sinks and the central shaded area rises up to a point inside the sunken area. See picture 18.

18

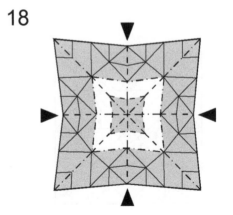

18. This picture shows the collapse in progress.

David Mitchell / Paper Crystals

19

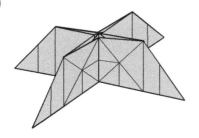

19. Your module should now look like this. Make sure the point at the centre is pointing upwards.

20

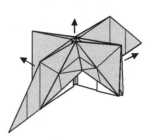

20. Turn the ends of two opposite arms inside out, then turn the tips of the arms outwards again.

21

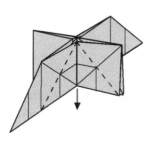

21. Pull the bottom of the front layers of the centre of the module towards you using the existing creases.

22

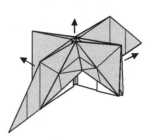

22. This is the result. Do the same thing in between the other arms as well.

23

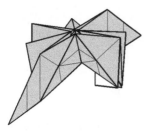

23. The result should look like this. The module is finished. Make two in each of three colours.

24

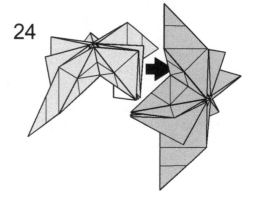

24. Begin the assembly process by putting two modules together like this making sure that all the corresponding parts of each module match up correctly inside.

25

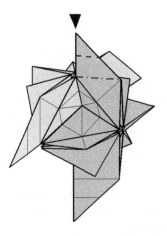

25. Invert and reverse out the ends of the upper arm of the outer module to lock the modules together. You may find that a thin blunt tool is useful to help ease the layers of the outer module completely inside the joint.

26

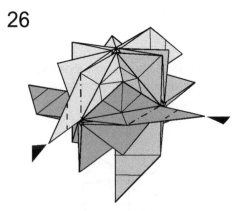

26. Add a third module like this. This third module is locked in place by inverting and reversing out one flap on each of the other modules.

27

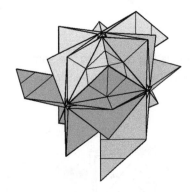

27. Continue to add the remaining modules one by one, being careful to maintain the pattern of the weave.

28

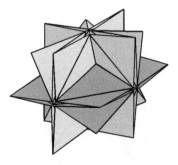

28. Once all six modules have been locked in place the assembly will look like this.

David Mitchell / Paper Crystals

29

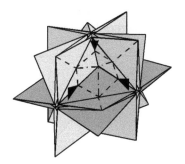

29. Transform the nearest corner by pushing the edges gently inwards like this. Make sure you don't create any new creases while you do this. A smaller square corner will form and the surrounding flaps will be pulled into collars. Curve the collars gently to hold the form secure. The look of the finished model depends on achieving a good degree of accuracy here.

30

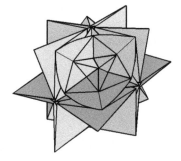

30. Transform the seven remaining corners in a similar way. As you do this the form of the Enigma Cube will gradually appear.

31

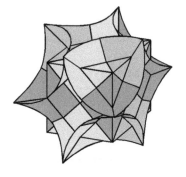

31. This is what the result should look like. To improve the finished appearance of the design, gently remake the creases inside the top, bottom and sides and work all the collars into smooth and even curves.

Enigma 12

You will need twelve squares of paper. These diagrams show you how to make Enigma 12 using four squares in each of three contrasting but complementary colours.

1

1. Fold in half diagonally, then unfold.

2

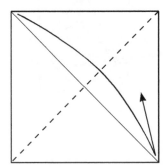

2. Fold in half diagonally in the opposite direction, then unfold.

3

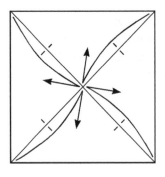

3. Fold all four corners into the centre one by one, then unfold, but only make tiny creases to mark the quarter way points of the diagonals.

4

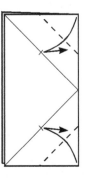

4. Turn over sideways.

5

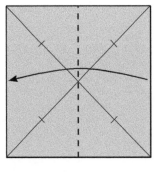

5. Fold in half from right to left.

6

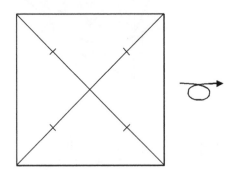

6. Fold both top and bottom right hand corners inwards like this, then unfold.

David Mitchell / Paper Crystals

7

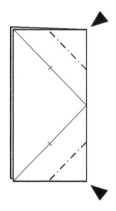

7. Turn both right corners inside out. You will need to reverse the direction of the creases in the front layer.

8

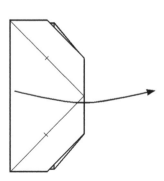

8. Open out sideways.

9

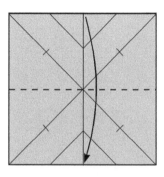

9. Fold in half downwards.

10

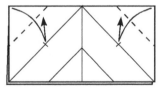

10. Fold the top left and top right corners inwards like this, then unfold.

11

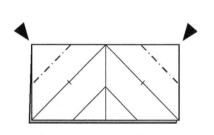

11. Turn both top corners inside out. You will need to reverse the direction of the creases in the front layer.

12

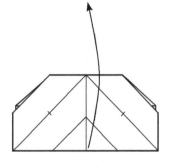

12. Open out upwards.

13

13. Turn over sideways.

14

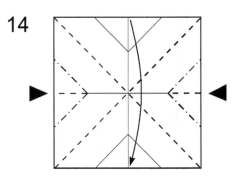

14. Use the existing creases to collapse the module into the shape shown in picture 15.

15

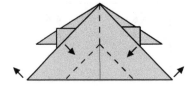

15. Curl the edges of the arms in the directions shown.

16

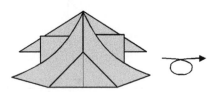

16. Turn over sideways.

17

17. Repeat step 15 on this side of the module.

18

18. This is the finished module. The tension in the creases should hold the curves in place. Make four in each of three colours.

19

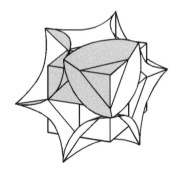

19. This diagram shows the relationship between a single module and Enigma 12 as a whole.

20

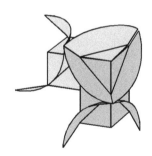

20. Two modules go together like this. Make sure the curve of all the collars is maintained during assembly. This will make the assembly process much easier.

21

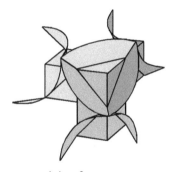

21. Three modules form one corner of the cube like this. If you maintain the pattern of the weave as you add the remaining modules the Enigma Cube will automatically form.

22

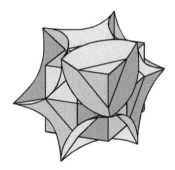

22. Enigma 12 is finished. When made well this is the most attractive of the three versions.

23

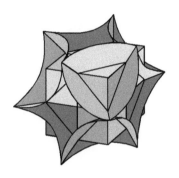

23. Enigma 12 can also be made using four modules in each of three colours.

20 Two modules go together like this.
Make sure the curve of the flap fits the curve of the adjacent module. This gives the shape shown in figure 21.

19 This diagram shows the interlocking between a single module and its flaps to make a whole.

21 Three modules form around one corner of the cube and if you maintain the pattern of the module's flaps and fit them all together the Crystal Cube will automatically form.

22 Six to 12 modules. When made well this is the most attractive of the three variations.

23 Cubes of light can also be made using four modules made in these colours.

Irregular designs

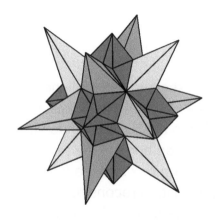

Odyssey

Odyssey is a very attractive hybrid design in the form of a pierced dodecahedron. It is made from thirty compound modules . The A modules are folded from 2x3 rectangles using standard folding geometry. The B modules are folded from squares but the secondary folding geometry that ultimately produces the form of the modules is that of the silver rectangle.

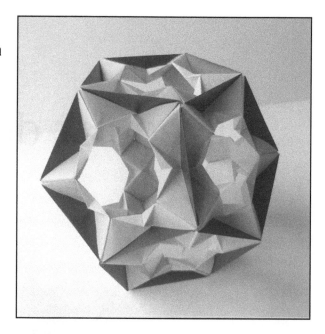

When I first designed Odyssey, in 1993, all the modules were folded from squares (there were more of them) and it lacked the decorative darts around the holes. I took it to a BOS convention to show it off, but, unfortunately, when I returned home, I made the mistake of leaving the finished model in an open top box and the family cat jumped in and comprehensively destroyed it. In reconstructing the design for this book I first added the decorative darts, then found that, with the darts added, it was more elegant to make the A modules from 2x3 rectangles.

In looking for a name for this design I played around with anagrams of the abbreviated word dodeca. The rearrangement oddace then suggested Odyssey, which fits rather nicely with the other Greek names in this collection.

You will need twenty-three squares, all of the same size. Fifteen of these squares, three in each of five contrasting but complementary colours, will be divided into thirty 2x3 rectangles to fold the A modules from. The other eight, of the same plain colour, preferably black or dark blue, will be divided into thirty smaller squares to fold the B modules from.

Folding the A modules

1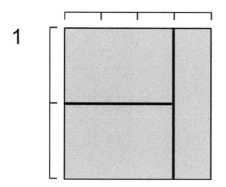

1. The A modules are folded from 2x3 rectangles. Two 2x3 rectangles can be cut from a square like this.

2

2. You will need thirty 2x3 rectangles in all.

3

3. Fold in half sideways, then unfold.

4

4. Turn over sideways.

5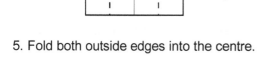

5. Fold both outside edges into the centre.

6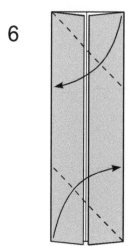

7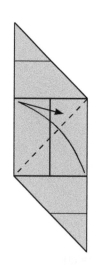

8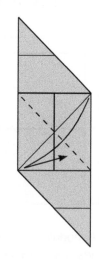

6. Fold the top edge onto the left edge and the bottom edge onto the right edge like this.

7. Fold the central square area in half diagonally like this, then unfold.

8. Fold the central square are in half diagonally in the other direction, then unfold.

9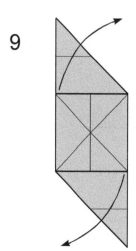

10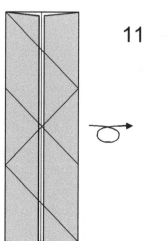

11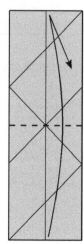

9. Open out the folds made in step 6.

10. Turn over sideways.

11. Fold in half upwards, then unfold.

David Mitchell / Paper Crystals

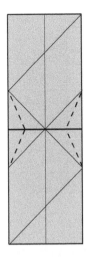 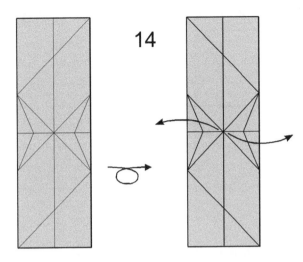

12. Make these four small creases by folding the outside edges onto the diagonal creases made in steps 7 and 8.

13. Turn over sideways.

14. Open out the folds made in step 5.

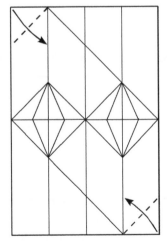 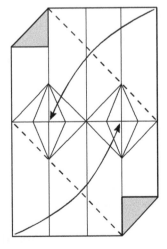

15. Fold the top left and bottom right corners inwards like this.

16. Fold the top right and bottom left corners inwards using the existing creases.

17

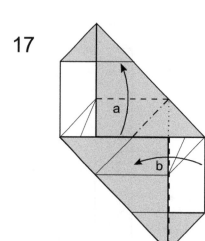

18

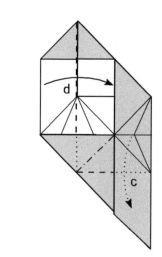

17. Make fold a in the front layer. This will automatically entail making fold b.

18. Make fold c underneath the new front layer. This will automatically entail making fold d.

19

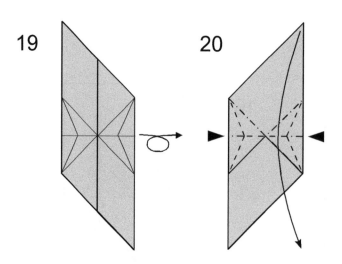

20

21

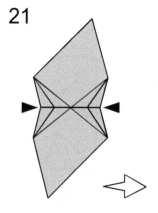

19. Turn over sideways.

20. Collapse the module into shape using the existing creases.

21. The collapse is underway. Continue collapsing until the module looks like picture 22.

David Mitchell / Paper Crystals

22

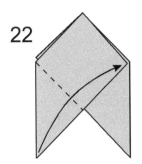

22. Fold the front flap in half diagonally like this.

23

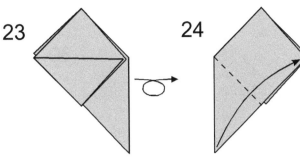

23. Turn over sideways.

24

24. Repeat fold 22 on the new front flap.

25

25. Open out to look like picture 26.

26

26. The A module is finished. Make six in each of five colours.

Folding the B modules

27

27. The B modules are folded from squares. If you start with a large square of the same size you used in step 1 you can divide it into quarters to make small squares of a suitable size.

28

28. You will need thirty small squares in a single plain colour, preferably black or dark blue.

29

29. Arrange one of the small squares like this. Fold in half diagonally, then unfold.

30

30. Fold in half diagonally in the opposite direction.

31

31. Fold the front flap in half diagonally downwards but only make a tiny crease at the left hand end of the fold.

32

32. Fold the top corner of the front flap downwards, using the crease made in step 31 to locate the left hand end of the fold.

33

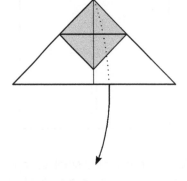

33. Fold the back flap downwards behind.

34

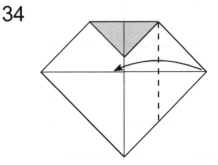

34. Fold the right hand corner inwards like this.

35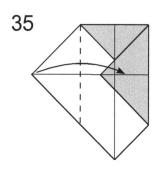

35. And the left corner inwards like this.

36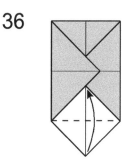

36. Fold the bottom flap upwards like this.

37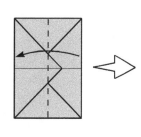

37. Fold in half sideways.

38

38. Fold both left corners of the front layer diagonally to the right like this.

39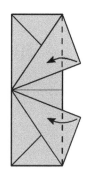

39. Fold the right corners of the front flaps inwards along the line of the folded edge behind them.

40

40. Turn over sideways and repeat steps 38 and 39 on the other half of the paper.

41

41. Lift up the front flaps at right angles. Do the same thing to the flaps at the back.

42

42. The finished B module should look like this. You will need thirty of these.

Creating the compound modules

43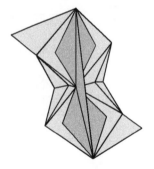

44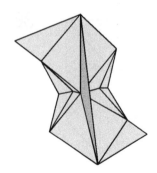

43. Lay one A and one B module together like this then tuck each of the flaps of the B module into the pocket behind it.

44. The compound module is finished. You will need thirty of these.

Assembling Odyssey

45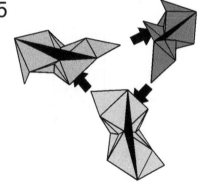

46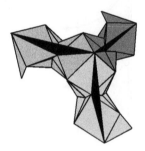

45 and 46. Three modules go together to form one corner like this.

47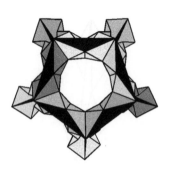

48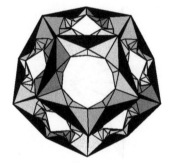

47. Five corners form a pentagonal ring.

48. Continue forming new corners and rings, keeping to the colour scheme shown, until Odyssey is complete.

David Mitchell / Paper Crystals

Curvaceous

Curvaceous is a hybrid design made from two sets of modules which begin from different starting shapes and are created using different folding geometries. The six A modules, which are folded from squares, go together to form a rhombicuboctahedron (see page 13) which is missing its triangular faces.

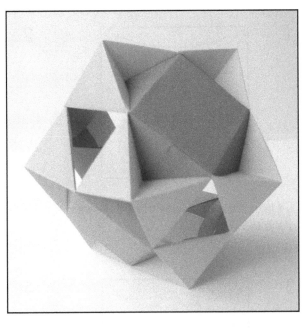

The twelve B modules are folded from silver rectangles. Two B modules are attached to each A module. They not only add beauty to the form, as well as the 'curves' for which Curvaceous is named, but also act to improve the integrity and stability of the design. These 'curves' arise because the angles of the faces are not completely aligned, which is, of course, the result of using hybrid folding geometries.

Curvaceous was designed in 1998. I experimented with several ways of attaching the B modules before settling on the way explained in the diagrams as the simplest and cleanest to fold and assemble.

Similar designs can be based on several other polyhedra, although, to my mind, the results are not as good.

You will need thirteen squares, all of the same size, six for the A modules, six which will be divided into silver rectangles to fold the B modules from, and one to use as a template. The template is used to help you create the silver rectangles. For the sake of clarity the diagrams show the A modules in one tone of grey and the B modules in another, but the best results are usually obtained by folding both sets of modules from the same colour of paper.

Folding the A modules

1

1. Make a tiny crease to mark the centre of the top edge.

2

2. Turn over sideways.

3
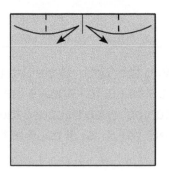

3. Make two further tiny creases to mark the quarter points.

4
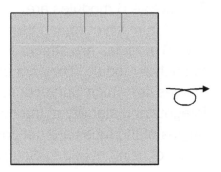

4. Turn over sideways.

5
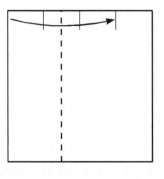

5. Fold the left edge inwards to the three quarter point.

6
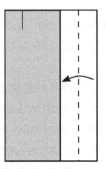

6. Fold the right edge inwards like this.

David Mitchell / Paper Crystals

7

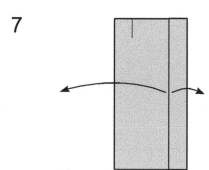

7. Open out the folds made in steps 5 and 6.

8

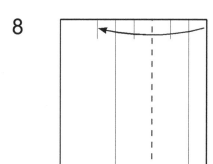

8. Fold the right edge inwards to the three quarter point.

9

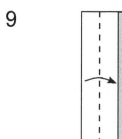

9. Fold the left edge inwards like this.

10

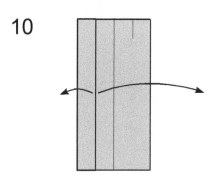

10. Open out the folds made in steps 8 and 9.

11

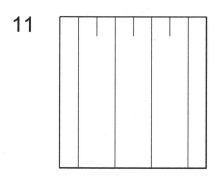

11. Rotate your paper ninety degrees so that the vertical creases become horizontal.

12

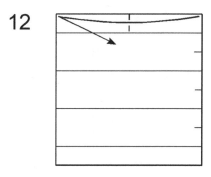

12. Make a tiny crease to mark the centre of the top edge.

13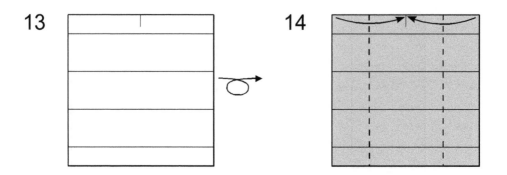

13. Turn over sideways.

14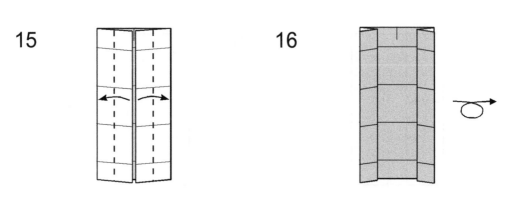

14. Fold both outside edges into the centre.

15

15. Fold both front flaps in half outwards.

16

16. Turn over sideways.

17

17. Fold both outside edges into the centre.

18

18. Flatten the folds making sure that the edges of the layers do not overlap each other in the centre.

19

19. Remake these folds through all the layers.

20

20. This is the A module. You will need six of these.

Assembling the modules

The next three pictures show how the A modules go together but you should not do this until you have added the B modules to them.

21

22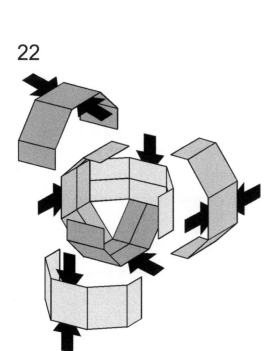

21. Three A modules go together like this.

22. The three remaining modules are added like this ...

23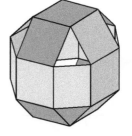

23. ... to complete the underlying rhombicuboctahedral structure.

Folding the B modules

24

24. Begin with the spare square. Fold in half diagonally, then unfold.

25

25. Fold the right edge onto the diagonal crease.

26

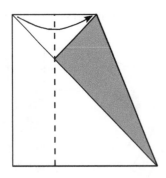

26. Fold the left edge inwards like this.

27

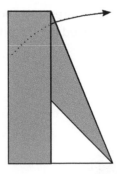

27. Open out the fold made in step 25. When this is done the template is finished.

28

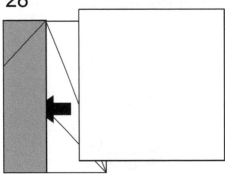

28. Slide one of the six squares you are going to divide into silver rectangles completely inside the template like this.

29

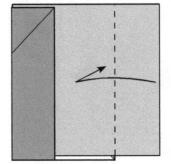

29. Fold the right edge inwards along the line of the right edge of the template which lies underneath, then unfold.

David Mitchell / Paper Crystals

30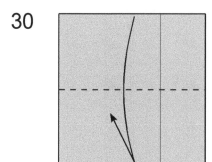

30. Remove the square from the template, fold in half downwards, then unfold.

31

31. Cut along the creases marked with thick black lines to separate the pieces.

32

32. You do not need the right hand piece. The other two pieces are the silver rectangles.

33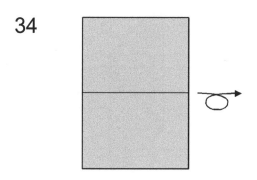

33. Arrange one of the silver rectangles like this, fold in half downwards, then unfold.

34

34. Turn over sideways.

35

35. Make a tiny crease to mark the centre of the top edge.

36

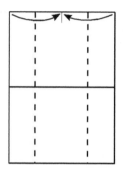

36. Fold both outside edges into the centre.

37

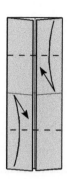

37. Fold both the top and bottom edges into the centre, then unfold.

38

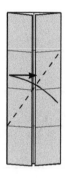

38. Fold the central section of the paper in half diagonally like this, then unfold.

39

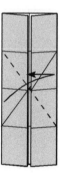

39. Repeat fold 38 in the opposite direction.

40

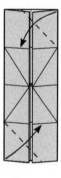

40. Fold the top right and bottom left corners inwards using the horizontal creases made in step 37 as guides.

41

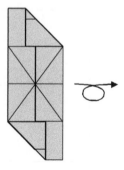

41. Turn over sideways.

David Mitchell / Paper Crystals

42

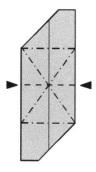

43

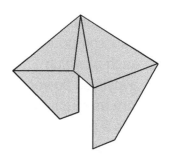

42. Collapse the module into the shape shown in picture 43 using the existing creases.

43. This is the B module. You will need twelve of these.

44

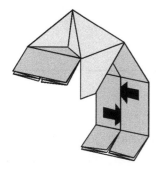

45

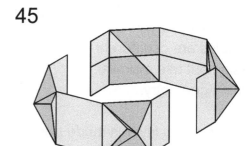

44. Attach two B modules to each A module, making sure that the arms of the B modules go underneath all the layers at the centre of the A modules.

45. Make six compound modules like this and put them together in the way shown in pictures 21 and 22 on page 121.

46

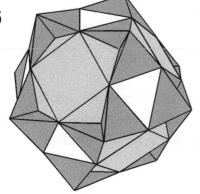

46. This is what the result will look like. Curvaceous is finished.

Q

Q is a hanging decoration made from six compound modules, each of which looks like a stylised flower. Q is therefore as much a kusudama as a paper crystal. Each compound module is made in three layers. Each layer of modules is folded from a square half the size of the one used for the previous layer. All the layers of modules are of different design but use a similar folding geometry.

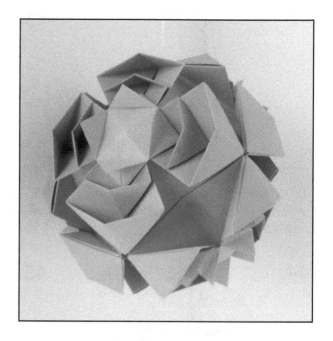

The structural layer is made from six modules which go together in much the same way as Gaia to form an eight-pointed star, although the outside surface of the modules, which provides the first set of petals, mostly hides this structure from view. The six modules of the purely decorative middle layer fit inside the structural modules and create a further layer of petals. (You can add additional middle layers if you start with large enough squares). The final layer of lock modules holds the compound modules firmly together and provides the flowers with a decorative centre.

Q was designed in 2001. Q is for kusudama, of course.

You will need fourteen squares of the same size altogether, six for the structural modules, six for the decorative middle layer modules (which are cut down to half size) and two more (to divide up into smaller squares) for the lock modules.

Folding the structural modules

You will need six squares of paper in the same colour.

1

1. Fold in half diagonally, then unfold.

2

2. Fold in half diagonally in the opposite direction, then unfold.

3

3. Turn over sideways.

4

4. Fold in half sideways, then unfold.

5

5. Fold in half downwards, then unfold.

6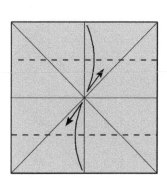

6. Fold both the top and bottom edges to the centre, then unfold.

7

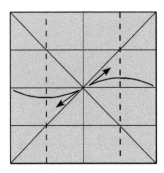

7. Fold both outside edges into the centre, then unfold.

8

8. Turn over sideways.

9

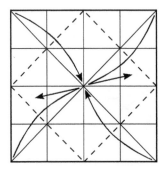

9. Fold all four corners to the centre, then open out just the top right and bottom left corners.

10

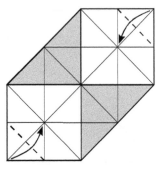

10. Fold the top right and bottom left corners inwards like this,

11

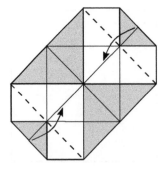

11. Fold the top right and bottom left corners inwards again using the existing creases.

12

12. Turn over sideways.

David Mitchell / Paper Crystals

13

13. Fold two opposite edges into the centre like this, then unfold.

14

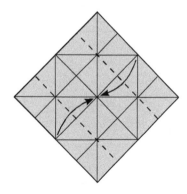

14. Fold the other two opposite edges into the centre, allowing the flaps at the back to flip into view.

15

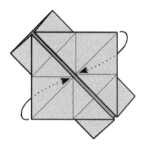

15. Undo the folds made in step 14.

16

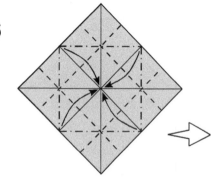

16. Collapse the module into the shape shown in picture 17 using the existing creases. Make sure you allow the flaps at the back to flip into view again.

17

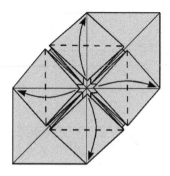

17. Fold all four front flaps in half outwards like this.

18

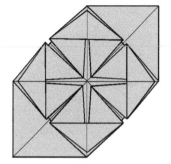

18. This is the finished structural module. You will need to fold six of these.

Folding the decorative modules

You will need six more squares of paper in a second colour.

19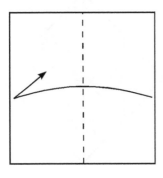

19. Fold in half sideways, then unfold.

20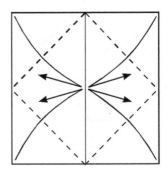

20. Fold all four corners into the centre, then unfold.

21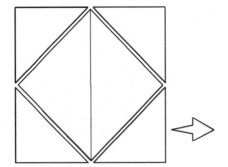

22

20. Cut along the creases to remove the half-size central square. Rotate this square to look like picture 22.

22. Follow steps 2 to 8 so that your paper looks like picture 23.

23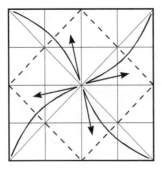

24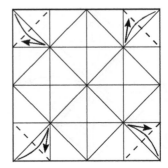

23. Fold all four corners into the centre, then unfold.

24. Fold all four corner squares in half diagonally, then unfold.

David Mitchell / Paper Crystals

25

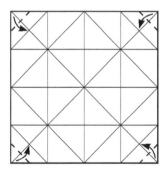

25. Fold all four corners inwards like this.

26

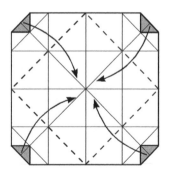

26. Fold all four corners inwards again using the existing creases.

27

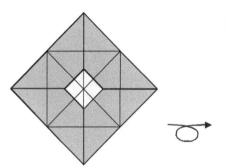

27. Turn over sideways.

28

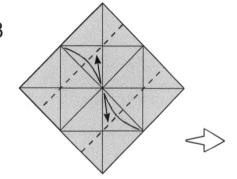

28. Follow steps 13 to 17, allowing the flaps at the back to flip into view at every stage.

29

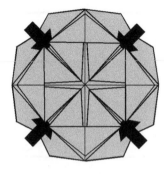

29. This is the finished decorative module. You will need six of these.

30

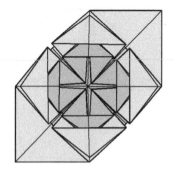

30. A decorative module fits into the centre of a structural module like this.

Folding the lock modules

You will need two more squares in the colour you used for the structural modules.

31

31. Begin by folding in half edge to edge in both directions then cutting along the creases marked with thick black lines.

32

32. You will end up with eight small squares. Only six are required.

33

33. Begin by following steps 1 to 8 then 23 to 25. Turn over sideways.

34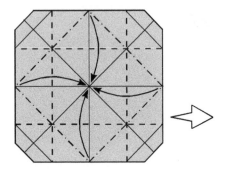

34. Collapse the paper into the form shown in picture 35, using the existing creases.

35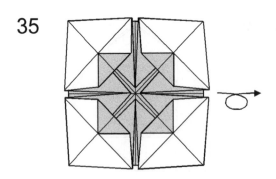

35. Turn over sideways.

36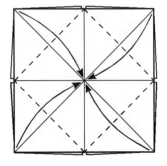

36. Fold all four corners to the centre, using the existing creases, and allowing the flaps at the back to flip into view.

David Mitchell / Paper Crystals

37

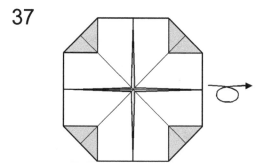

37. Turn over sideways.

38

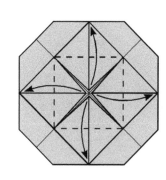

38. Fold the four centre flaps outwards like this.

39

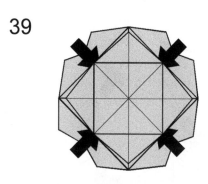

39. The lock module is finished. You will need six of these.

40

40. The lock module fits into the centre of the decorative module like this.

41

41. Shape the module by pushing the sides of one set of petals inwards like this.

42

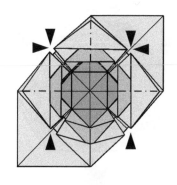

42. Do the same thing on the other three sets of petals.

43

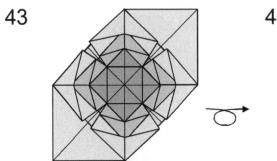

43. Turn over sideways.

44

44. Collapse the bottom layers of the compound module into the shape shown in picture 45 using the existing creases.

45

45. The tabs are marked with circles and the pockets with arrows.

46

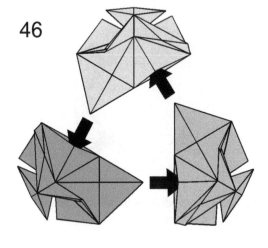

45. Three compound modules go together like this.

47

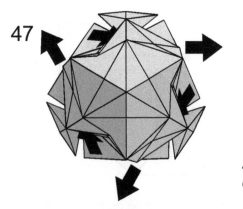

47. Continue adding modules until Q is complete.

David Mitchell / Paper Crystals

48

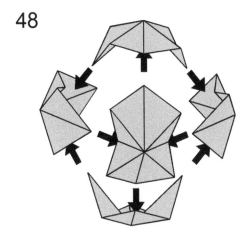

48. The underlying structure of Q is the same as that of Gaia.

49

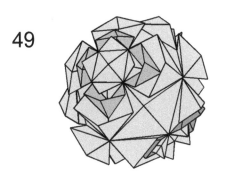

49. When Q is complete it should look like this. The underlying structure is not visible.

Hanging Q

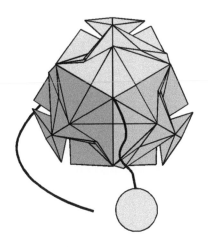

50. Q is designed as a hanging ornament. Q is best hung using a large round bead or polystyrene ball attached to a thread. The thread passes through the point of one of the pyramids formed where three modules meet. When the module is hung the bead is pulled up into the pyramid and the pressure on each of the modules is equalised so that the design hangs evenly.

Lightning Source UK Ltd.
Milton Keynes UK
UKHW03f1121060418
320622UK00005B/496/P